UNIVERSE SERIES ON WOMEN ARTISTS

Louise Bourgeois

UNIVERSE SERIES ON WOMEN ARTISTS

Louise Bourgeois

PAUL GARDNER

UNIVERSE

On the front cover:
Femme Couteau, 1969–70
Carved pink marble
3½ x 26⅛ x 4⅞ inches
Photo: Allan Finkelman
Emily and Jerry Spiegel Family Collection
Courtesy Robert Miller Gallery
Photo of Louise Bourgeois from the collection of Paul Gardner

First published in the United States of America in 1994
by UNIVERSE PUBLISHING
300 Park Avenue South
New York, NY 10010

©1994 Universe Publishing

Designed by Christina Bliss, Jolie Muller, and Tad Beck

94 95 96 97 98 99 / 10 9 8 7 6 5 4 3 2 1

Printed in Hong Kong

Library of Congress Cataloging-in-Publication Data

Gardner, Paul,
 Louise Bourgeois / Paul Gardner.
 p. cm.—(Universe series on women artists)
 Includes bibliographical references and index.
 ISBN 0-87663-639-3
 1. Bourgeois, Louise, 1911- —Criticism and Interpretation.
I. Title. II. Series.
NB237.B65G37 1993
709'.2—dc20 93-2081
 CIP

Contents

DEDICATED TO
KEVIN ECKSTROM

Although I've interviewed Louise Bourgeois for many articles and lectures, the times I remember most fondly are conversations over dinners and on wintry walks; mornings in her studio and evenings in downtown clubs. She is a stimulating and often surprising companion.

A citation to Jerry Gorovoy for his advice and solidity. And my appreciation to the Robert Miller Gallery, particularly Diana Bulman for archival research.

At Universe Publishing, Adele Ursone was a thoughtful and creative editor. Honors to her colleagues Bonnie Eldon, Ellie Eisenstat and Tina Bliss for her meticulous art direction.

I'd also like to thank John Willenbecher, Lila Edwards, Lynn Bonsall, Caroline Blackman, and Mark Greenberg. Michael McLaughlin, Virginia Liberatore, Duane Michals, and Max Hutchinson deserve mention for their voluntary support.

A special salute to Steven Packard who, amid keen scrutiny and counsel, brought to my attention the French proverb: "To want to forget something is to think of it."

*Cell
(Eyes and
Mirrors)*
1989–93
(work in
progress)
Marble,
mirrors,
steel, and
glass
93 x 83 x
86 inches
Photo:
Peter Bellamy
Courtesy
Robert Miller
Gallery, New
York

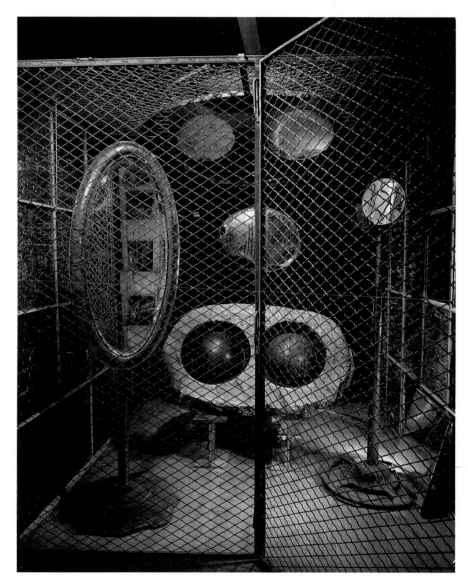

Through the

Looking Glass

"Curiouser and curiouser!" cried Alice.

—Lewis Carroll

When Louise Bourgeois steps inside her studio, she passes, like Alice, a grave little child with golden tresses, through a looking glass that lands her in an enchanted and hallucinatory world. But it is a world of Louise's own making.

The heroine of the Lewis Carroll story was maddeningly curious, fiercely forthright, and at times, downright stubborn: she had to find out what life was all about for herself. Though Louise Bourgeois is somewhat older than Alice—and seemingly durable as stone—with long brown hair folded into a plait or pinned into a bountiful French roll, she distinctly evokes many of Alice's most

endearing and exasperating traits, like being too precocious, even now, for our own comfort.

As a child, Louise accepted life as a strange, marvelous, terrifying adventure. She grew up in an atmosphere where not much was forbidden or hidden. What she discovered or imagined or dreamed—visions that shaped her state of mind—continue to be realized in the surreal exclusivity of her studio amidst staircases that lead nowhere; dismembered limbs; headless women; random body parts; and ghostly, abstract wooden figures that could impale a person. To an outsider entering for the first time, it is all baffling, sexual, chilling—and teasingly inviting. To Louise Bourgeois the studio is definitely *home*.

"I'm up around seven or eight in the morning," she says, "I'm always raring to get into the studio. It is a pleasure, although some days the energy is not as big as the ambition." Bourgeois lives on the West Side of Manhattan in a Chelsea town house, and she commutes to her Brooklyn studio—two floors in a vast, high-ceilinged plant where naval uniforms were once made. The studio is flooded with light from warehouse-size windows and from banks of fluorescent tubes that once illuminated rows of sewing machines. Covering 15,000 square feet, it's a treasure trove of metal, bronze, wood, and marble objects, all tidily grouped upstairs or down with a spiral staircase between.

"It is a privilege to be an artist, the government shouldn't have to pay for it," she continues, casting a formidable eye on the spectacle around her. An electric teapot steams up hot water for instant coffee that she may have with a bite or two of a croissant. But inside the studio food is forgotten, along with impolite intrusions of the outside world, which ceases to exist. Unlike many painters and sculptors she does not work to the blare of music or TV. That would be positively agonizing. Her environment is supremely silent, except for the whistle of a teapot, quickly

unplugged. Almost ritualistically, she roams in a circular fashion around works-in-progress—caressing and scolding her developing friends, her growing family of art.

Dressed in a smock, slacks, and sneakers, she gazes intently —beaming, frowning, pursing her lips—at objects that she knows as well as herself. And as her day gathers momentum, she wields a hammer with startling strength and a chisel with exacting precision. Her hands are charged with character: small and solid, deeply graven and scuffed, with a long lifeline, they are the hands of a fearless toiler who understands the roughest instruments and the rawest materials. They are capable and curious hands that know how to control the most delicate or hostile dare.

"When a work is finished, it leaves," she says meekly, as a fact that must be accepted like everything else in life. Then, hands thrust into the pockets of her smock, she asks with amused annoyance: "When is a piece finished, *at last?*" She looks stern. Her voice becomes confidential. "Aah, that depends on how *I feel* about it! Whatever you see, I am allowed to change. That is my privilege. I repeat the word 'privilege' because art is a privilege to do what you damn want. If people appreciate it, if it sells"—she raises her shoulders toward heaven, she raises her eyebrows, too—"that is something else."

Though driven to and from the studio weekdays by an assistant, she had the spunky nerve, until the late eighties, to make the ride home alone by subway. Some mornings she stays in her Chelsea house to work on drawings and sketches for commissions. An hour or two is set aside to meet curators from Europe and other parts of the country. She may grant an interview ("I've had it," she mutters, "no more interviews, what *more* can I say?"). However, she's selectively receptive to college students, mostly young women, who find her a role model as they pursue art and art history. The telephone never stops its piercing jangle. Louise, pacing,

Louise Bourgeois

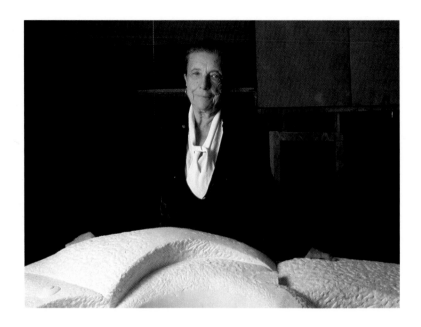

finds herself wrapped in a cobra-length cord. "The studio is peaceful. In New York the phone rings and it is always someone making a demand." She sighs, a musical, fretful French sigh that would silence trivial chatter at the salon of Madame de Sévigné.

Louise Bourgeois, who first emerged as an important Modernist sculptor in the mid-forties and whose painted wooden, vertical assemblages preceded those of David Smith, according to some art scholars like Alfred Barr, finds that an extraordinary number of people are making demands, especially after she was chosen to represent the United States in the 1993 Venice Biennale, the oldest, most prestigious of international art festivals. She's now praised as a sculptor ahead of her time. Ironically, until 1978 Bourgeois had only eight solo shows in New York in thirty years. There was scant reference material on her when art sleuths began careful scrutiny of

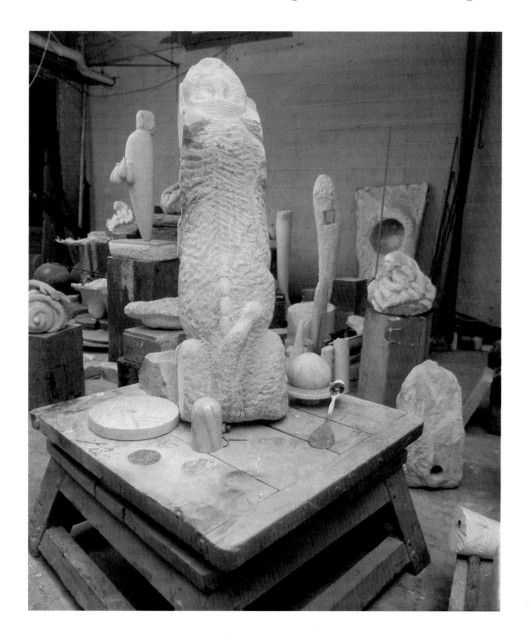

her work in the late seventies. That changed abruptly with a retrospective at the Museum of Modern Art in 1982. Nowadays, museums and collectors seek out her sculpture, paintings, drawings, and prints—work that often calls to mind the dark wit of Ionesco's plays. Today she holds a fistful of awards and honorary degrees. Still, she waited almost a lifetime before she finally was recognized as a solid "art star" in the eighties. Our national bugaboo is a fixation on youth; the art world constantly looks for the newest foxy young thing, of fleeting fame, to stir up the market. Her belated acclaim is a parable of perseverance.

Immediately after she was tapped for the Venice exhibition, the media sent up huzzahs and called attention to her age—a remarkable, indeed, inspirational fact. "Making It at 80" trumpeted one headline. She was not thrilled. She was dismayed. "Making it," she echoes the phrase with disgust. "What's the fuss about? I'm not twenty-five. Yes, I have been on the fringe." Relaxing, she adds a melancholy note, "It could have come earlier." She grins slyly. "As you get older, you get better—like a French wine. I feel like a rich woman, because I can say what I think. *That is the meaning of making it.*"

Her celebrity does not come from a glamorous, cuddly art. It is deliberately aggressive and perverse. The breadth of her work constantly amazes. It ranges from the abstract wooden "presences" (or *personnages*) to provocative nature studies, often breastlike or phallic, which she calls "divertissements of the body." The art historian and curator Henry Geldzahler once told her that there were pieces he'd rather not spend a half-hour alone with. "That's good," she responded, with a solemn daintiness.

Her five-hour day is interrupted only by a lunch break at a Greek cafe. If she's feeling satisfied with herself creatively, she permits a knowing waiter to bring her a treat of baklava. In the studio, where time and conventional notions of reality vanish, she works

on several pieces at once, taking her time, going from marble to wood to metal, depending on her mood as she cuts and carves her metaphors for isolation, violence, anxiety, sex, and cruelty. Examining the passages carved through a marble chunk, which send a fine white, snowy powder to the planked studio floor, she then takes a charcoal marker and draws lines where she will strike deeper into the marble. Louise Bourgeois is on a psychological "dig."

The passages represent approaches to solving a problem, to seeking illumination. The challenge stimulates her. "To understand a person we try many ways. Now, why should we understand someone else? Two reasons. First, the most primitive. You want to eat the other one. The second is more civilized. It is to seduce. *That* is a problem. I have a taste for the mechanism of seduction. I consider, 'Louise, how will you seduce that stone and make it a work of art?'"

An admirer of La Fontaine, whose fables resonate with acute and droll observations, Bourgeois enjoys recounting "tales" that she heard or made up or that she uses to explain the heartbeats and heartbreaks of her life. To further explain the artistic problem, she announces: "The Story of The Juggler and the Virgin." A riveting storyteller, her voice drops to an absinthian mezzo. "The poor juggler is challenged by the virgin. Whether he wants her or not is beside the point. But he would like to get from her a sign of recognition. For years he practices juggling, with many defeats. Finally, one day, the virgin cracks a smile. For the juggler the tension of years of work is released. At last he got what he wanted." She pauses, raising a finger to her lips for a moment. "So I do not want to use the stone for my own purposes. I want to bring out its highest potential. And I do this with my tools. But always there is resistance. The urge to please someone, to want someone is very strong. Seduction is never finished. But I am attracted to resistance."

The rest is silence.

Louise Bourgeois was born in Paris in 1911 on Christmas Day. She grew up on the Left Bank, in St. Germain-des-Près, in a building next to the Café de Flore, long before it was made famous by Jean-Paul Sartre. In those days St. Germain was provincial—everyone flocked to the cafés in Montparnasse or, for something more gaudy and shocking, if that's what you wanted, you crossed the Seine and, on the Right Bank, trudged up the hills of Montmartre. The novelist Evelyn Waugh recalled that on the summit of Montmartre you could find purple flowers, red berries, and plenty of love for sale.

Most of her childhood was spent in Aubusson and by the River Bièvre near Paris—"a large forbidding house"—where her mother, Josephine, and a staff of women restored sixteenth and seventeenth-century tapestries that her father, Louis, found in the stables and on the walls of crumbling châteaux. "The river passed by the tanneries, so its water had special chemical qualities, tannin content, and wool dyers used that water." The now tattered 20-foot-high tapestries had been used to warm damp walls and cover horses during freezing winters. When Bourgeois was ten, she was asked to help with the restoration. Her first assignment was to redraw a foot that had been withered away by time. Meticulously, she began to draw feet—or whatever else was missing from the romantic figures of courtesans and cavaliers.

"I was useful. My parents and the craftswomen trusted me." By the end of World War I, when tapestries were appreciated as a decorative art, the family had a thriving business. "There was never enough money to spoil us. There was just enough not to talk about it. Besides, it is indiscreet, decidedly not French, to talk about money. You may think about it, though." The tapestry workshop gave her a sense of design and an awareness of a geometric style later known as Art Deco that became internationally endorsed at a decorative arts exposition in Paris in 1925. Influ-

enced by the order of Egyptian and Aztec arrangements, Art Deco emphasizes grace and elegance—qualities the French elevate, beyond politics, when asked, as it sometimes happens, "What next for France?" A unity of style, *naturellement*.

She had an older sister named Henriette. Typical of the French, who frequently treat their offspring casually, giving a nuance to the phrase "extended family," she recalls that poor Henriette was always parked somewhere, with grandparents, relatives, and there was little brother Pierre—"a major disappointment." Louise, the middle child, was named after her father and became his favorite because she looked just like him. "Maman liked me for the same reason. It was a fact she exploited. We had a tradition of having charming, stylish men in the family. Papa was quite a charmer. He had many mistresses." Her blue eyes—speculative, rueful, tender—announce that she has outlived the best and the worst of surprises. She can veil reactions to anything unpleasant.

"Maman gave me confidence. I still remember her love and being held closely. My father would often make me feel small. Then Maman would explain, 'Men are like children. You have to humor them.' And this is true. You have to feed them, tell them they are great, you literally have to take care of them. I mean, it's really a job. Maman was very practical, as are most French women. My father had his affairs which she ignored, but it had an effect on all of us." Feeling betrayed by her father and disturbed by her mother's acceptance, she was emotionally lost—caught between two people she loved. She insists that how much you care for another person depends on a mutual sense of trust. "Trust is important to me. When it is not there, I am frightened, I retreat, I hide. Now after Maman became ill, we spent winters in the south of France and I had an English governess. Her name was Sadie. She was supposed to teach us English, but she was there for my father.

Louise Bourgeois

Cote d'Azur. On the
promenade at Nice in
the early twenties.
Louise with her brother,
father, and the highly
upholstered "governess."
"*A civilized ménage,
characters created by
Colette? No, I do
not say that.*"
Collection of
Paul Gardner

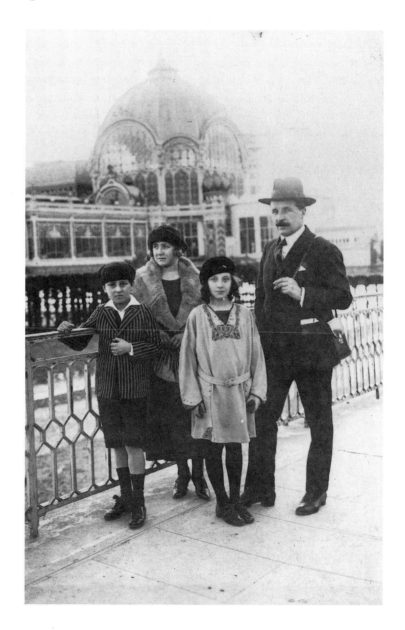

She lived in our house. She rode in the coupe with him, in the front seat. Maman and I sat in back. *I hated her*! But Maman knew it was much easier to keep an eye on Papa this way. It kept him from running around. A 'civilized' ménage, characters created by Colette?" she asks with a savage laugh. "No, I do not say that. Later my mind, as an artist, was conditioned by that affair, by my jealousy of that dreadful intruder."

Smartly attired in ruffles or velvet dresses, with a beret or ribboned hats, young Louise joined the fashion parade along the promenades of Cannes and Nice, traipsing to flower and auto shows with her parents and, she adds scornfully, "That other woman." She never revealed her feelings. For some, it is said, being well-dressed offers a serenity that even religion is powerless to bestow. But her wardrobe provided no inward tranquility. The formalism of *esprit* is more consoling than automated spirituality. Her mother always advised Louise to be reasonable ("*sois raisonnable*")—after all, common sense and the relevance of reason, particularly when it's needed to smash a rival, had been advanced by Racine. Her endurance plan worked, sort of. "I learned that the way to survive is to make yourself indispensable to someone else. My father needed me. I pleased him. I was never rejected. But it often made me sad."

Life with Papa had sad, sobering moments, but it was never staid, hence Louise's preference for New York's "downtown scene" (from Chelsea to lower Manhattan) rather than pearly sprees in gilded midtown canteens. For a night out she seeks the smoky, cavernous clubs, featuring jazz, funk, and progressive rock music, where the atmosphere is amusingly illicit. "It is because of Paris. Everything I do was inspired by my early life." Her father, a dashing boulevardier, wanted to teach his young daughter "the ropes." He would take her to the *boîtes* of Pigalle and Montmartre. The great painters there were either dead or had moved away, but the area's

reputation—gangsters, tarts, tourists, and American jazz singers—
still made it a midnight haunt.

"He'd take me to the cabarets and say, 'Louise, what you see
here, this is the world.' And I learned there is wisdom in this
milieu. There was also mystery. I remember one dive in Pigalle. A
drunken businessman demanded to see all 'the girls' for hire. Now
this man rejected the most beautiful. Next he rejected the little
pretties. Finally he shouted, 'That one!' And she was—I swear to
you—the most ugly of the lot. I thought, what kind of person can
he be? So I became very curious, very interested in certain peo-
ple. Not the ordinary, the commonplace, the bores! Who cares
about them? In the *boîtes* you can study human nature and some-
times see close friends change before your eyes." She suddenly
throws her head back, grinning mischievously, roguishly. "I like
that," she states.

But the Left Bank (or *Quartier Latin*) near Saint-Sulpice and
in the Luxembourg Gardens—where nannies wore lace caps and
boys launched toy sloops in the spring, and the chestnut trees were
heavy with white blossoms—this was where Louise Bourgeois
experienced lyricism and poetry. And on sunny afternoons she'd sit
quietly on the terrace of a café sipping hot chocolate. Somewhere,
out of sight, a student band played tunes, usually by Massenet.

Having absorbed philosophy in the lycée, she went on to
study mathematics at the Sorbonne because "you could trust the
principles on which it is constructed. It is a reliable system. It will
not betray you." The year was 1932. She was twenty and her
mother had just died. "Mathematics represented a world of order
that I wanted." Yet Paris offered far more than calculus and solid
geometry. Paris, an intoxicating bohemia for American expatri-
ates Fitzgerald, Hemingway, Robert McAlmon, and Djuna
Barnes, among others, had become "a great machine for stimulat-
ing the nerves and sharpening the senses," writes the critic-essay-

ist, Malcolm Cowley. "Paintings and music... fabrics, poems, ideas, everything seemed to lead toward a half-sensual, half-intellectual swoon."

In the mid-twenties, the poet André Breton had published his first manifesto of Surrealism, in which the uncontrolled imagination reigns above all. The only laws an artist need observe were private ones—the laws of art. The crazy excitement drew a lively, young international set: Magritte, Dali, Man Ray (an émigré from Brooklyn), Luis Buñuel, Giacometti, and Max Ernst. They contributed to the Surrealist "swoon."

If Louise Bourgeois's psyche seems hopelessly inscrutable at times, it must be remembered that her personality, if not her art, remains connected to the Surrealist movement, which reached a feverish pitch in Paris when she was a reflective gamine on the Left Bank. Surrealism explores the dream, the nightmare, the dark side of reality, the erotic side of fantasy. It is a world, Max Ernst once observed, where "everything is astonishing, heartbreaking, and possible." Referring to such themes in her work as anxiety, frustration, and sexuality, Louise quickly adds, "I think my work world is very real. There is isolation and loneliness, and, yes, cruelty. You experience cruelty with people you love because you do not get what you want. You cannot extract an admission of love from another person. But my memories, my sculpture," she insists, "relates to my life before I married, before I came to America."

While Paris crackled to the explosion of modern art—for Surrealism together with Cubism was transforming not only painting and sculpture but also the theater, movies, and literature—Louise Bourgeois asserted her individualism. Her first step: she moved into a studio in the rue de Seine where her landlord was Isadora Duncan's brother Raymond, who roamed St. Germain in a toga, his long hair flowing. Parisians still talked about Isadora, strangled by her own scarf in a freak car accident on the Riviera in

1927. She had liberated dance with spontaneity, passion, and the naked body. Opening up dance to all women, specifically respectable women, she preached: Express your emotions deeply, freely in art.

The second step for Bourgeois, a major one, came in 1936, at the age of twenty-five, when she began studying art history and art at the Ecole des Beaux-Arts and the Grande Chaumière in Montparnasse. Bourgeois didn't exactly leave mathematics. "It simply went into a theoretical world I had no use for," she says. "In order to stand unbearable family tensions, I had to express my anxiety with forms that I could change, destroy, and rebuild." On most afternoons at the Grande Chaumière, Louise worked by herself in an isolated studio, making clay figures from Greek and Roman antiquity. She also recalls a sketch class "where you had to produce something in five minutes. After the meaningless discipline of the Ecole, I found this freedom very exciting. The atmosphere was alive. And you had to prove you had something to say."

First a scholarship student and later a teaching assistant, Bourgeois was given the job of selecting the models. "They were all prostitutes, with chalk skin, purple lips, orange hair. Now, most curious, their emphasis was always on *cleanliness*. This is amazing, no? I learned even more about life. I learned that the most promiscuous people seem to have a fetish about cleanliness."

As a student in Montparnasse (the *quartier* immortalized in Hemingway's *The Sun Also Rises*), she was not far from the Closerie des Lilas, a popular café where André Breton, the self-appointed founder of Surrealism, wrote and expostulated on poetry, and argued about aesthetics and ethics. "Breton!" exclaims Bourgeois, with an exaggerated gesture. "He was the Pope in the cafés. You had to serve *his* purpose. Max Ernst was around, too, but he was a bit of a climber." They paid no attention to Louise Bourgeois. In that avant-garde clique women were only seen as sex objects,

providers of francs, and dutiful hostesses (*"Du thé, messieurs, des gateaux?"*). With her silky hair, delicately boned face, and petite frame, Louise was certainly decorative and sexy, but she was also deliberately cool and aloof, with no intention of becoming a groupie. She disdains groupies of all sorts. When they think (rarely), they think alike. She much prefers the stupendous oddball.

Her art education included a period of study with Fernand Léger. The experience had its dramatic moments. "He could never pay the rent for his atelier. So his brood of students followed him in and out of Parisian ateliers. With his students, Léger was distant and puritanical. But he was also pleasant and reassuring. Léger turned me into a sculptor. It happened this way: one day he took a wood shaving—it was like a lock of hair—and he pinned it up under a shelf where it fell—freely in space. We were told to make a drawing of it. I was very interested in the spiral of the shaving, the form it took and its trembling quality. I did not want to make a representation of it. I wanted to explore its three-dimensional quality. And so I did. I knew from this exercise that I would be a sculptor, not a painter." As for the teaching of art, she insists it cannot be taught. "You have to work with the potential of your students and develop it." Of all the art schools where she has given critiques, she only recommends those that offer no degrees. "If you are degree conscious, it hurts creativity."

In 1938, during the last days of European peace, Louise met a young art historian from Harvard named Robert Goldwater who was completing his studies abroad. "I felt he was someone I could trust." She does not allow herself to be sentimental, but the memory gives her a special radiance. "He told me his father had never been unfaithful to his mother. I couldn't believe this was true, but it made me interested in him."

Picasso had recently completed *Guernica*, Jean Renoir had opened *La Grande Illusion*, and Sartre was completing *La Nausée*

when Louise sailed across the Atlantic and found herself a married woman in a new world.

Do you know the New York sky? You should, it is supposed to be known. It is outstanding. It is a serious thing. Can you remember the Paris sky? How unreliable, most of the time gray, often warm and damp, never quite perfect, indulging in clouds and shades; rain, breeze, and sun sometimes managing to appear together. But the New York sky is blue, utterly blue. The light is white, a glorying white and the air is strong, and it is healthy too. There is no foolishness about that sky. It is a beautiful thing. It is pure.

So begins another Bourgeois "tale" called *The Puritan*, written in 1947, with a variety of flavors, about the New York sky and later a building, a house, and a good man who worked in a "factory of refinement"—a museum. Her phrasing, which has a childlike simplicity, moves with literary ease, airiness, and irony without any mawkishness. It is clearly her "voice," her perception, her nature.

And New York was something

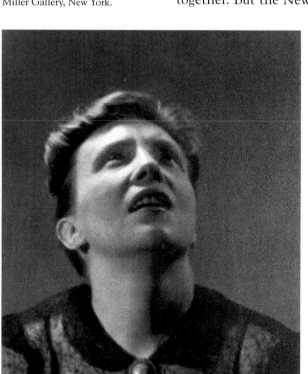

"Do you know the New York sky? It is a beautiful thing." Portrait of Louise Bourgeois by Berenice Abbott. Courtesy Robert Miller Gallery, New York.

to behold! Whereas Paris was then a city of perfect symmetry, of gold and silver-gray buildings and labyrinthine gardens with stately rows of clipped limes, New York was an astonishing pop-up book of towering glass skyscrapers of every shape, size, and style. Instead of lime trees, Louise saw a grid of cement and asphalt. The elevated trains rumbled along avenues, and gritty tenements were covered with dangling ladders and stairs called fire escapes. Were there no fires in Paris apartments? Maybe. But certainly there were no ugly escape routes that ruined the architecture. And sirens! You did not hear sirens in Paris, you heard twittering birds.

A small woman, about five-and-a-half feet tall, Louise found herself always looking up. At first she felt lonely and alienated. And yet the violent energy and motion of New York, the masses of people hurrying somewhere, nowhere, the constant physical changes of tearing down and rebuilding the ultimate metropolis appealed to her sense of the paradoxical. To get along, she realized, you had to instinctively *feel* the city, not try to understand it.

Though a farmhouse was later acquired in Connecticut, she seldom leaves New York. The country is where people go when they want to be good and feel plain. "I cannot work in the country. It would cause me more anxiety than New York. I stay here all year. There is safety and danger, passivity and aggression all around. *This* is what exhilarates me." And the Chelsea area where she resides, with its open markets, flower stalls, bistros, disreputable bars, and the nearby fur district recall her favorite Paris neighborhoods rolled into one. She first lived on East 18th Street next to the old Third Avenue "El." On that building's roof she began her long wooden pieces. "The roof had a haunting quality. It was the size of the roof and the loneliness of that roof that enabled me, in the early forties, to start sculpture here."

Within a few years she had three sons—Michel, Alain, and Jean-Louis. Her husband, "a wonderful, reasonable, rational man

kept the house together," she declares intensely. But the formidable juggling act as artist, mother, and wife was hers. She carried it off, with all manner of artists and scholars drifting in and out among rushing and tumbling children. Passing through were the literary elite—Edmund Wilson, Mary McCarthy, Dwight Macdonald, Kay Boyle, Lionel Trilling. Gradually there were grudging aperitifs with émigré Parisians, exiles in America, who colorfully challenged the artistic landscape. Remembering earlier slights, Louise viewed the arriving pooh-bahs of Paris skeptically. Breton, Ernst, André Masson, Marcel Duchamp—"it was the Left Bank again, and although I was now close to them, I objected to them violently. They were so lordly and pontifical."

Once, out strolling with Duchamp, she spied two snails in the act of jiggery-pokery. Feeling vexed that day, she stamped on them. Duchamp cleared his throat and inquired, "Why such exaggeration? It's not necessary to be that emotional." Bourgeois does not recall what caused the outburst or the year it occurred. The snails may have simply been in the wrong place at the wrong time. However, the early fifties, when she became an American citizen, had their anxieties. She had been grilled at naturalization hearings about possible Leftist acquaintances. Bourgeois confronting pudgy investigatorial faces sounds like an episode in a screwball comedy, but it was the Red Scare era. Her answers were courteous and candid, but the scenario stirred up an angry sense of invasion, an encroachment on privacy, which the French value as much as freedom.

Besides their insistence on privacy, the French have qualities readily apparent in Bourgeois. As the novelist Edith Wharton pronounced, these include an almost Chinese reverence for the ritual of manners, intellectual honesty, an insistence on caution to the point of secretiveness, and an ideal formed of continuity and taste. "If you want to interest the person you are talking to, pitch your voice so that one person will hear you." This observation, Wharton

asserted, contains all there is to say about taste. She further perceived, as Louise had already learned, that a person of sensibility can rebel without threatening society.

As a rebel Louise concedes that she revels in controversy and scandals that tweak the Establishment. In 1989, by the time a blunderbuss Southern senator made the relatively unknown name of Robert Mapplethorpe known to the most remote fisherman in the Bering Sea, Bourgeois had posed years earlier for the photographer. She donned a fluffy fake fur and then cradled a plaster and latex sculpture that resembles an erect phallus titled *Fillette* ("Little Girl," 1968). The contradiction, she explains, is a comment on the sexes, "because they are so mixed today." Her photograph, frequently printed with the prominent member and other parts cropped, is less startling for the sculpture itself than for the look on her face. About her lips plays the sunburst of a smile. Bourgeois's smile absolutely makes the Mona Lisa's become an exasperating smirk. If the picture offends, well then, it is the prerogative of vulgarians to be shocked.

Bourgeois became an art "presence" at the end of the forties with a solo show of her wooden figures, or *personnages*. It was arranged by a young man named Arthur Drexler, who later joined the curatorial staff of the Museum of Modern Art and was director of its Department of Architecture and Design. Captivated by the simple, slender, stemlike forms—each imbued with a distinctive personality—Drexler was impelled to visit the woman who had created what art historians now describe as the first environmental work.

"I stepped into her studio," he recalls, "and it was like finding myself in a strange movie by Jean Cocteau. There stood this very small, intense woman—extremely svelte, handsome—wielding a huge *cleaver* with which she worked on balsa wood. She was alarming as she attacked the wood with a kind of innocent magic that

Louise Bourgeois

was obsessive, yet also poetic. I was crazy about her work, but I didn't stay long. I remember thinking that when I entered her studio it was like passing through a mirror into another world."

She continued working and showing sporadically over the years, but Bourgeois, with her European sensibility and passionate self-determination, ignored any signature style and opposed current trends. The New York School (the Abstract Expressionists) emerged in the postwar years with strong, expressive work by Jackson Pollock, Franz Kline, Tony Smith, Mark Rothko, and Willem de Kooning. They saw the making of art as an energetic affair for "real men."

Boozing, womanizing, the flexing of artistic muscle (personal demons be damned) were traits that defined the temperament of many of those who were later acclaimed "giants." Their bravura strokes of paint and fine constructions expressed textural richness and a keen all-American confidence. Neither the Abstract movement nor Minimalism (which prompted John Cage to reflect, "I have nothing to say and I am saying it") related to Louise Bourgeois, who willfully refuses to belong to any school. She was and still is a loner. The handful of other women artists around quickly took up the current movement. Assuredly, they were not producing "nature studies" of the body that left the Gentleman Critics uncomfortable. It just didn't seem right for a woman sculptor to find the body—any body, any part—so fascinating.

And Bourgeois was never pushy. She did not kneel before the High Priests of Art. "A private vice is my self-defeatism. I'm more afraid of success than failure. It's not serious enough to see a psychiatrist about, but it's a great drain on my energy. So. What do I do. I think about it a lot. Self-defeatism doesn't go against creating the work. It does, however, make one fearful of showing, and I am a shy person anyway. That's why I have many pieces I've never exhibited."

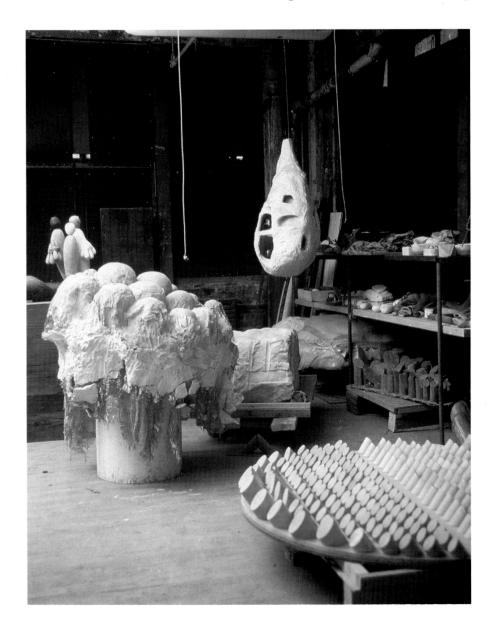

Louise Bourgeois

Louise Bourgeois is notoriously bad at public relations. Pity the dealer who expects her to charm a potential collector. Despite moments of irascibility when tired, she's usually, in the words of Mrs. Malaprop, the very pineapple of politeness, and says little. "What can I say to collectors? I don't know *why* they collect. And critics? A critic is a rare and sensitive bird. I never know what to say. The only way to meet a critic is not to think of yourself. You have to be detached, debonair, and self-assured. Never talk about yourself. Draw the other person out. What works best for success *today* is if the artist is handsome or very beautiful. You must look good on magazine covers. Ah, I'm not supposed to say this, but it's true."

If you find yourself seated next to her at dinner how do you put this shy *papillon* at ease? Avoid the obvious subjects like art, and aim for the uncommon or mystifying. The iguana you just acquired would surely arouse her interest. Or an obscure *film noir* where the hero says, "Whichever way you turn, fate sticks out a foot to trip you." At one buffet she withdrew from the sparkly guests and moved to a remote corner. A science professor joined her, prattling about obesity in rats. She listened raptly. The hostess swooped down: "Pssst—Louise—" and motioned to some Texas millionaires hovering near a platter of cold salmon. They looked rather lonely—and available. "Oh—yes," she muttered vaguely. "They are *not* interesting. If they want to buy, they buy. Now, I want to hear more about the rats."

Shy and idiosyncratic, yes—but the essence of Louise Bourgeois is her strength. With miraculous energy she forged a new life after her husband's death in 1973. Only in the studio could she forget her loss. Over the years she used everything from paint to plaster to deal with childhood memories and her move to a new world. Now, in the studio, she returned to old themes with different materials and surprised viewers with creations where the

humorous becomes macabre and the submissive image turns out to be quite ferocious. "Yes, I am a sadist, because I am afraid. I am afraid and then I spend my time repairing. For me, producing sculpture is an exorcism." Ignoring fads and fashions of the fickle art world, and remaining most stubbornly herself—therefore, an outsider—she became a highly visible *insider* in 1978 when a venturesome young dealer named Patricia Hamilton not only gave her an exhibition but also urged her to stage a happening, or "fashion show" around the environmental work titled *Confrontation*.

The day before the opening that helped elevate Bourgeois to her present stature, she telephoned Hamilton at eight o'clock in the morning. Hamilton was humming to herself while squeezing fresh oranges for her refreshing wake up when the phone rang. "Pat, I can't possibly be ready," said Louise. "The show is off." Never one to mince words, Hamilton exclaimed, "Like hell it is. The announcements are out. It's half installed. Ready or not, Louise, I'm opening your show." When Patricia Hamilton arrived at her midtown gallery, she found Louise sitting in the middle of the room, fondling a plait of hair and weeping. "She was scared stiff," explains Hamilton. A former cheerleader, Hamilton immediately gave her a buck-you-up talk, and with renewed assurance Louise set to work. "She pulled it off, *natch*," declares Hamilton exultantly. "It was great."

With this exhibit, Bourgeois was swept into the mainstream of American art. *The New York Times* critic John Russell wrote: "In a quiet way, Louise Bourgeois is one of the most distinguished artists around, and by a long way, one of the most intelligent." Bourgeois, whose own world was somewhat closed, autonomous, and self-sufficient, had to adjust to the spotlight of the art world. Her self-confidence remained as fragile as the day she sat sobbing in the Hamilton Gallery. She does not doubt her inner strength; she doubts her own value. The result is an anxiety about her

accomplishments and what is expected of her. "An artist who believes all the flattery, when it comes, does not last long," she once said decisively.

Her repeated comment on the "privilege" attached to being an artist is easily understood. She means that, to a certain extent, creative people can make their own rules for a life. They don't have to answer to an authoritarian "code" imposed by despicable tyrants. "You can still make a hash of your life," she warns, "but it's *yours*." Then she adds briskly, turning away, "Of course, an artist can be hell to live with. There is nothing else he or she can do." Her eyes flash. "So. That's it."

Louise lived by her rules, but in her multiple roles she has for years respected all the social requirements. For posh museum functions, attended with her husband, she presented herself with Parisian chic. Every detail of her *toilette* was perfect of its sort. The same can be said of her deportment. Though few may have been allowed to see her early studio work, Louise Bourgeois herself was a wonderful creation. Following her husband's death, her personal "image" underwent changes as she leaned toward a more casual, bohemian, and at times, punk idea of style, reflecting complete liberality. But it's her presence—like her wooden "presences"—that is awesome and intimidating.

Her face. It is less a *visage* than a monument to her talent. It now appears hammered out of rugged rock in which the superimposed lines represent stories of self-possession, obsession, distressing decisions, and hard efficiency. It charts the graph of her soul. And, like a disciplined actress, she knows how to use her face, along with her rhythmic voice, to "seduce" the most normally resistant person.

For some years she has been filming selected people in situations that she arranges. It will be a whopper Bourgeoisian epic. Invitations to appear are treated with deceptive nonchalance: no one's ever going to see this stuff, be a sport, it will be *très amusant*,

non? The most resistant people are seduced. She lured an astute critic, a woman also known for her feminist posture, to her Chelsea digs for a video-taped lunch, *à la* the film *My Dinner with André.* "We will discuss the issues," Louise said persuasively, and the critic's reluctance vanished. What could be more satisfying than discussing "the issues" with Madame Bourgeois? Asked by a colleague how the video lunch went, the critic enthused: "She's quite precious." On the tape, the two nibble exquisite finger food, the conversation temporarily gets knocked endways, and soon the critic is dozing away in her chair. Screening the sequence months later for a friend, Louise announces her verdict. "It is beautiful. We see that she is vulnerable."

There's also the tale that could be called "The Leopard and The Monkey"—another example of her commanding persuasiveness. A screenwriter she knew kept rejecting any video session. Then one day she showed him a coat made of monkey skins, on loan from a furrier. "Feel the skin, so lovely…a fur coat for a man." He stroked. "Now, try it on." He did. She put on an old leopard coat. "In animal skins, we are different, you'll see." They perambulated down Fifth Avenue. It was a day of blue skies and ripping breezes. Nature smiled on them. In Greenwich Village—before it was taken over by fast food joints and sidewalk flea markets—they took refuge in the last swank restaurant, now gone. A cameraman appeared and filmed "the Monkey." He had been waiting there. The seduction was complete. Clad in their furs, the Leopard and the Monkey ordered champagne and oysters. And, for a while, the furry little creatures were content. "The Monkey wanted to be free," says Louise, "so he scampered away." She never wore the leopard coat again.

Actually, Bourgeois is more intrigued by animals than their coats. She sees a relationship between them and us, from the predatory qualities to a need for protection. In her Chelsea house,

she prowls like a stealthy cat from room to room, then drifts into her garden, observing the kingdom of squirrels and birds romping in the trees. On the terrace, outside French doors, she secretly studies diverse young visitors inside. Sometimes she offers cheese and olives. Sometimes nothing. "I live on endive, leeks, yogurt, fruit. The less you eat, the better you feel." If anything hot is served to her pals, like steamed vegetables, it comes from a pressure cooker. "One cannot live without a pressure cooker," she once admonished a musician.

Long ago, when her family was there, cooking amused and relaxed her. "But when it came time to serve the food, I would lose confidence in myself. I once made a *boeuf à la mode* and spent all afternoon preparing it. When it was time to eat none of my family would come to the table. I was angry at first, then hurt, so I took the *boeuf* and threw it out the window. Just at that precise moment the children came in the door. They did not understand that waiting for them to like my food was agony for me. They were so surprised. So much work and so much time wasted for such a result!"

Louise Bourgeois observes repeatedly that her American life has been "uneventful," that her art is solely rooted in childhood traumas. Her statement is true as far as it goes, but it would be naive to believe it's the full story. After hearing frank interviews about her youth, many art journalists wondered, as Peggy Lee sang, "Is that all there is?" Nonsense. Louise is too cunning, too discreet, in sum, too French, to ever lay bare her dossier, or anything else, for the public. Her personal revelations stop at an age when most people have mature emotional murmurs. To believe that she remained untouched after her teens is to accept the easily imaginable. Discussing her work, Louise, with a nod to André Gide, urgently advises, "Don't understand me too quickly."

One of her most disquieting works is a rarely seen group of etchings, surreal rather than literal, titled *He Disappeared into*

Complete Silence (1947). The portfolio catches the loneliness and alienation of a frightened figure who wears no recognizable face. Each etching is accompanied by a fable. A sample of their cankering complexity:

> Once a man was angry at his
> wife, he cut her in small pieces,
> made a stew of her.
>
> Then he telephoned to his
> friends and asked them for a
> cocktail-and-stew party.
>
> Then all came and had a good time.

Louise Bourgeois lives among poetic fragments—fragments of work to be completed, fragments of sealed memories as recent as yesterday, of relationships to be resolved, and fragments of love that are always perilous. The things she dreams about are more beautiful, blasphemous, and perhaps more satisfying than the reality that lies beyond the real.

Outside her Brooklyn studio, sheets of rain splatter against the windows. A deep, monotonous refrain of the roaring wind shatters the silence inside. She goes to a large marble and scrutinizes a passage she is drilling through the solid stone. "Winning or losing, I don't know, the point is to get yourself through the passage." She shivers slightly. "Who would choose to be an artist? Who would choose that fate? If you asked Verlaine, he would say he certainly did not choose—he was fated. 'I did with the poor means I have.' The artist is not a neurotic. To be an artist is a guarantee of sanity." Despite the painful choices, Bourgeois is in accord with the hero-

Eccentric Growth
mid-1960s
Red ink on paper
9 ½ x 13 inches
Photo:
Zindman/Freemont
Private Collection

ine of Guy de Maupassant's classic *A Woman's Life*: "You see, life is never as good or as bad as one thinks."

The rain has finally stopped and sunlight streams through the windows. Time for her visitor to take the subway back to Manhattan. That afternoon an assistant would be arriving. He'd have all the keys. The question is how to get her friend out from behind the looking glass of Louise's world before then. The windows are barred. They hurry up and down corridors. She sees a door to the basement staircase and mumbles something in French.

"Excuse me, but I always swear in French." She deftly unbolts a forbidding metal door. It creaks open a few inches onto a weedy lot strewn with debris and won't budge any further. In the gloom of the basement the two look at each other. "I knew I'd find a way," she says as he wedges himself through the opening. Outside he turns around to say good-bye. The door is bolted.

Louise Bourgeois has disappeared.

Untitled
watercolor on paper
19¼ x 25⅜ inches

Courtesy Robert Miller Gallery, New York

Intimacy

Representation of the world, like the world itself, is the work of men; they must describe it from their own point of view, which they confuse with the absolute truth.

—Simone de Beauvoir

odern American sculpture, with its emphasis on sheer power, suspension, and movement, seems to have sprung from a man's world. The handling of "macho" materials—bronze, steel, marble, wood, and sheet lead—would appear to demand masculine know-how and strength. Consider the giant stabiles of Alexander Calder; the crushed auto-body parts of John Chamberlain; the huge beams of steel rods of Mark di Suvero; the granite biomorphic forms of Isamu Noguchi; and the slabs of David Smith, once lauded as the most impressive sculptor America has produced. However, there's more to this story, and it begins with the work of Louise Bourgeois, who influenced, at times turned upside down, this male-dominated art form with her point of view. Whacking away with hammers and

chipping away with chisels, her pockets crammed with nails, sand-paper, and files, she is a pioneer woman who flouted convention by venturing into male territory—an international territory of Rodin, Brancusi, Giacometti—and triumphed.

Impersonal men tease the mind with concepts without ever touching the heart. Defiantly personal and daring with her ideas of intimacy—which sometimes offend viewers and leave critics fum-bling for euphemisms—the feisty Bourgeois says, "I am only my work." As a young Parisian, she studied mathematics because she felt that geometry offered a reliable world. Later, as an artist adjust-ing to her new personal and physical surroundings in America, she stressed her interest in "the achievement of finding an order out of chaos." Sorting out all the chaos—often with doubt as her passion and her passion as the task—she produced a body of work from her subconscious mind that rings of independence

With her ceaseless curiousity, the studio—not the kitchen, nursery, or bedroom—was her moral support, her safeguard against any loneliness or pessimistic wonder and dismay. Bourgeois is endowed with a toughness that seldom accompanies the most sen-sitive kind of talent. Few survive the system of the art world; even fewer are considered at the height of their effective powers once they are past the age of sixty. She successfully challenges all the hollow rules. Louise Bourgeois has always known better than any-one what she's doing and where she's going. "I do what I can, I give what I have," she murmurs. "Inspiration? It seems to me that art is created with a capacity for feeling, for processing pain, and express-ing experience and memory." She creates her own idiom in marble and stone and wood. Her invention of form, encompassing abstrac-tion and figuration, has a remarkable timelessness that speaks to the youngest artist today.

Mention her name and a slew of images, not one or two, flood the mind: beyond her wooden "presences," her spirals spin-

ning in space, and lairs for secrets and seclusion, there are her women who are part houses with flying, magical, powerful, beautiful hair, some with arms; her installations of staircases with no safe exit in sight; her sculpture of gender duality; and her ironically exaggerated landscapes of the body. She offers a rich "muchness" from a ceaseless imagination. All her pieces are extremely personal and intense. "I am an intimist," she says, with an aching intentness. "Being an intimist, my motivation is not to communicate. Communication never happens anyway. By definition it's something you wish for. I want to have total recall and control of the past. Reality is more beautiful than fiction. You have to see to believe." She reaches out to grasp her vision with the surety, the precision of an architect. If prudes wrinkle their noses at umbilical coilings that also seem scatalogical, she is considerately indulgent. She never worries about how far too far she can go.

The scholarly Robert Rosenblum, professor of art history at New York University, says, "It's hard to measure Louise against anyone today. She doesn't fit into any category. She's a phenomenon, a force of nature—like Niagara Falls." Bourgeois, who refuses to "fit," and most curators and critics have an easier time with artists who do, steadfastly ignores the tides of trends in the art world, thereby maintaining an enduring modernity that makes Rosenblum think of her as "an Old Master among us."

Bourgeois describes herself as "a lone wolf" who strongly believes that if an artist finds a style and keeps at it long enough, she—or he—is likely to find fulfillment. Style, argues Schopenhauer, is the physiognomy of the mind, and a safer index to character than the face. She was aware of herself as a "woman artist" before feminism was around. With her inbred French *philosophie*, she observes, "Women's art was important when it wasn't an issue, but it isn't important now because it became an issue. There is always so much conformism to what seems popular." She mod-

estly accepts being lauded as an Old Master, but she'd find a door to slam in the face of any fool who thought Old Madame or Old Mistress was a more politically correct phrase. Over a sandwich in a Chelsea bistro a block from her home, she complains — with steely tolerance—that some people would deprive the language of any subtlety. She admires a Pascalian reflection that perfect clarity can be damaging — in language, life, and art. Louise Bourgeois refuses to grow old. She refuses to think *old*. "The only way to stay young, in spirit, is to understand what the young are up to. I like to know what turns young people on. The more rebellious they are, the more I like them."

Sunday afternoons are open house in Chelsea, but you should have an invitation or she may not answer the doorbell. Her Chelsea house, a hub of sociability and a sanctum for meditation, has, at its center, a somewhat mad *mélange* of students and strippers, movie directors and scholars. It's now her *own* Left Bank setting. She truly enjoys the company of worldlings in their twenties and thirties who display a playfully aggressive attitude toward fashion and music, who scorn convention with a phony switchblade glamor. "They are nice," she declares simply. For her, it's honesty above hypocrisy, always, and if you can't be honest, then, at least, shut up.

Being very attuned to the ways of the world, she is unlikely to give sanctimonious advice or even a headshake. During the eighties she lost close friends, artists and scholars, to the AIDS epidemic. Like many, she was unprepared for the tragic vanishings. It all seemed unthinkable. But so, too, was the occupation of France when friends back home were rounded up in midnight raids and never seen again. Vanished. "The subject of pain is the business I am in," she remarked in 1991 before exhibiting a series of what she termed *Cells* instead of *Lairs*. A Bourgeois *Cell* might include a barren cot—symbol of birth, sex, death—with a table of glass

beakers. The glass represents tears, fragility, the liquids of the body, a challenge to our own self-restraint and an opposite to the eternal quality of stone. Another *Cell* focused on a craggy marble piece with a protruding marble leg. "Here in the arch of hysteria, pleasure and pain are merged," she whispers.

Her mixed-media *Cell II* (1991) centered on a low, round glass-topped table holding perfume bottles and clasped marble hands. All the *Cells* are surrounded by doors, some made of glass. "The glass lets you see inside, it tells the truth." For Bourgeois, the death of someone close is abandonment rather than loss. "When my mother died in 1932, this rage to understand took me over. If you fear abandonment, it keeps you in a state of dependency, which makes you feel you are unable to cope. So there is this rage of not knowing how to live up to your fate. This pain never goes away, and you don't know what to do about it. The perfume is the opposite. It's the evanescence of pleasure. The sense of smell has the great power of evocation and healing." Her highly charged installations continue the mystique of autobiography, but they are immediately universal.

"Sick people die of the need of companionship, a stroking hand, a hungering for compassion," she says, adding that they're isolated by fear and that they run away from people. Her mother was ill and used to cough up blood. Bourgeois helped her hide the illness from Papa. Her *Cells* enclose psychological and intellectual pain. "When does the physical become emotional? It's a circle going round and round. Pain cannot be relieved. It can't be eliminated or suppressed. It's here to stay."

Religion cannot help. The generous French attitude is that, under the best circumstances, it does no harm. She is frostily governed by reason. The unfathomable is of little interest. There are many religions, she explains, and each claims to hold the Answer. "They have nothing to tell me. They can show me nothing. I say

L o u i s e B o u r g e o i s

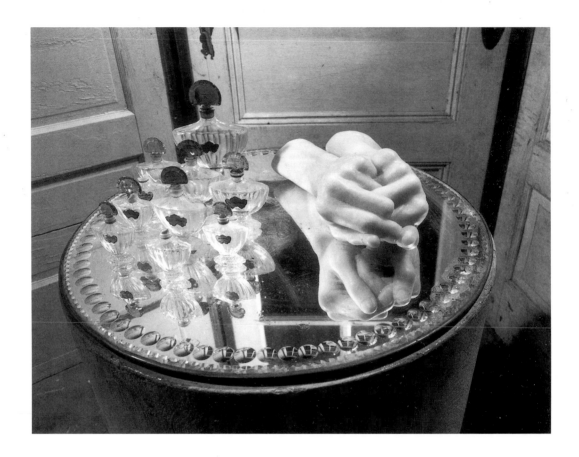

Cell II
1991
Mixed media
83 x 60 x 60 inches
Photo: Peter Bellamy
Collection of the
Carnegie Museum
of Art, Pittsburgh

no to all: *I will express myself*! My religion is psychoanalysis." Her vigilant blue eyes harden. There is nothing her eyes are not acquainted with or armed against. Her eyes state, as did Voltaire with his pen, that there is no heaven, but let's act as though there was one to deserve.

"Don't confuse heaven with the notion of paradise," she says. "Heaven is a belief." Swiftly, curtly, she rumbles, "That's it!" The subject is closed. But heaven is an irrelevancy, anyway, attached to

a dogma that cannot be proved. "Can you prove it to me?" she would demand. A collage of her life and the spontaneous, flowing images coming from her many-sided mind, images that she can remember or hold or strike—or compulsively love—are of the tree, the house, and the figure. Obviously, the house (with its lairs and cells) provides the stage set for crucial relationships of domestic drama.

She presents the personalities bared, unadorned, without superfluity. And from each house, Bourgeois—or someone whose loveliness is being whittled down—tries to flee. The landscape rises and falls and whirls into spinning spirals. Jerry Gorovoy, her knowledgeable assistant and confidant, having explored her exterior, came upon a window of interior understanding. "The landscape, the spiral, and the eye all symbolize the constant flow of life, energy, and time," he discovered. "The tree is a woman: the branches are her hair, the roots the source of life within the earth. The tree is therefore eternal; it symbolizes the conscience, guilt, and reparation." The habitat of the body and the surrounding country make up her private mythology as she goes through the looking-glass, establishing symbols and fixed patterns.

On her hazardous, dark journey she reminds us that her vision alters with the changing cycles of life; that you aren't the same person this year as last, nor are those you love, or those you think you love. Can a changing person still love another changing person? If this reverie is pursued, it can only be transformed into a Bourgeois fable that has a sad ending. For the only thing sadder than the death of someone is the death of dreams, and the death of love itself.

After settling in New York in 1938, a city where she pushed fear away by looking up, up, up and scanning the sky, and then seeing herself in relation to the stars ("That is the way I make use of

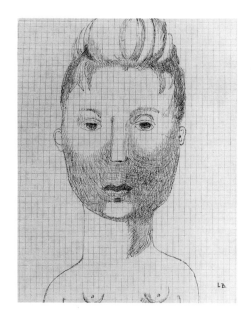

Self Portrait
1942
Ink on graph paper
11 x 8¹/₂ inches
Photo: Zindman/Freemont
Collection of
Galerie Lelong, Paris

geometry"), she continued a kind of student life at the Art Students League, recording the past and present, on her own flight from house to studio to nursery to art school and home again. She was drawing, painting, printmaking, a circling artistic flight among pen, ink, charcoal, and oils. Many years later, she pulled from a drawer where it had been forgotten, an intimate self-portrait set down on the gridded paper of a French notebook. "The grid is very peaceful. Nothing can go wrong. Everything is complete," she says. Her expression on paper is one of careful, controlled politeness. Once again, her unflinching eyes dominate the drawing, suggesting that she knows more about life than anyone could possibly imagine.

During this period, from the late thirties to the early fifties, her male and female figures, her bulbous and penetrating forms, knotted landscapes and hirsute bodyscapes, are rendered expressionistically or abstractly, with arousing undercurrents of the unconscious. Stylistically, she is finding her own niche—eccentrically her own. Aesthetically, she is considering motifs that will emerge again in her sculpture. The polarity of passive and aggressive, fecundity and subjugation, tenderness and rage, are all present. What was she working toward? The great novelist Joseph Conrad, within his domain, supplied the answer: "A meticulous precision of statement." For that alone will "bring out the true horror behind the appalling face of things."

A short but shattering trip that reveals a portion of her inward-outward search begins with *Reparation* (1938–40), in which a young girl, another Louise, is seen holding a sprig of flowers before a tomb (her grandmother's grave)—or is it a hopeful token

of love before a closed door? The painting is done in affecting shades of blue: turquoise, deep blue, sky blue, and blues with purple and foamy splashes of white. The child is without any facial expression. There's no sloppy sentiment, only quiet heartbreak.

Then in *Roof Song* (1947) the child is grown up. Hair flying, she is exploding like a puff of smoke from a red brick chimney or a house afire, with an unnaturally feline grin of contentment on her face. She's free, at last, a blithe spirit, escaping into the night. And yet, the grin is deceptive. It seems glued on like a mask. For only a masked grin can hide a scream. Fly away home. But where is home?

After nine years in New York's male-dominated art world, Louise realized that in order to be accepted—and noticed—specific people had to be cultivated. In her view, only gardens are to be cultivated. New York's social scene, where collecting went on over canapes and drinks, was presided over by women, as it still is, and Bourgeois found the Pompadours of Park Avenue "very lazy, sometimes stupid." They needed, she saw, to be entertained and flattered by men. (Today they have art consultants on a tight leash.) The male artists, "the buffoons," she calls them, danced attendance with obsequious bows. She stayed away. Bourgeois is not a mass-kisser.

Yet, she concedes, almost apologetically, an awareness of her masochism is necessary to the understanding of her work. She felt that, although the world doesn't need more children, it was a privilege to have them; it was a privilege to be an artist; it was a privilege to be part of a marriage that was *right*; and, ultimately, maybe it was wrong for her to have so many privileges. An artist needs courage to take risks, to remain independent. Privilege, a word she uses often and ceremoniously, worried her. "So you deny yourself—deny your sex—deny yourself tools to save money for the family."

Her frustration and confusion are announced in her *Femme-Maison* series. The English translation is usually given as Woman-

Louise Bourgeois

Reparation, 1938–40
Courtesy Max
Hutchinson and
Robert Miller Gallery,
New York

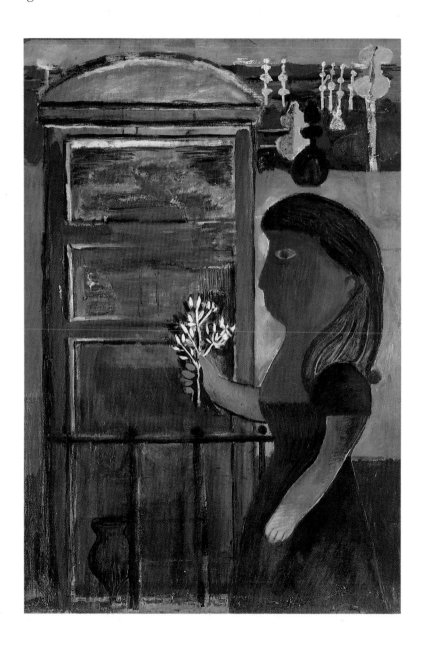

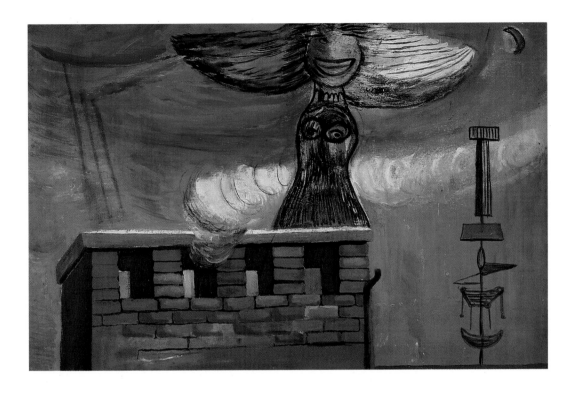

Roof Song
1946–48
Oil on linen
21 x 31 inches
Photo: eeva-inkeri
Private collection

House, though *femme* in French can be either "woman" or "wife"; it depends on vocal nuance and context. Claude Chabrol's eloquent crime-of-passion film, *La Femme Infidèle*, refers to an unfaithful *wife*. During the forties and fifties when radio and television schedules were clogged with quiz and giveaway programs like *House Party*, *Queen for a Day*, and *You Bet Your Life*, the emcee, with chipmunk teeth, asked women contestants, "And what do you do?" Mustering dignity, the women responded, "I'm a housewife" or "I'm *just* a housewife." Housewife was a routine ID for every married woman in America who did not work outside the home. Bourgeois could not have missed hearing the phrase on radio, TV, or among neigh-

bors who described themselves as housewives, since it was an accepted part of the national vernacular.

To Louise Bourgeois, who remembered her mother and aunts and the chic married ladies who sipped Cinzano at the Brasserie Lipp, across the street from her Parisian home, the banality of the word must have been humiliating. The French *femme* would rather admit publicly that she was someone's mistress than proclaim that she was this curious dreadnought called "housewife." A married woman in Paris who did not work aspired to be known as *une femme du monde* like the Marquise de Rambouillet, who took pride in her salon accentuated by polished manners, verbal spark, and courtly feelings. But that was France. How could anyone hazard to tell emcee Art Linkletter in Hollywood, "What do I *do*? Oh, I'm a woman of the world."

Still, Bourgeois, with her solemn adaptability to the American middle class, saw with ghastly clarity the accuracy of the word *housewife*. "Woman House" carries a nicer sound, but it hardly conveys the panting and puffing, the peculiar battle with broomsticks that only a housewife endures. Louise's early *Femme-Maison* paintings (1945–47) portray the naked bodies of women whose identity card is not a face but a house: They're half-women, half-house—some with arms, others with waves of hair, wondrous protecting hair, shooting through the roof. The house as a sustaining structure, a smothering space, a refuge, is a compelling symbol in her work.

She likes the idea of collecting houses. She vividly remembers her family house in Paris and the Côte d'Azur where she vacationed with her parents, a sister, a brother, and Papa's mistress. "My memories of houses are not always pleasant. There is anxiety and fear and a need for privacy. Houses represent security. My studio in Brooklyn is not exactly a house, it is a refuge. Women must own something. A woman cannot rent. It's—" she halts, searching for

le mot juste—"obscene to rent. So, despite tragedies within a house, or my own fragilities, it is a storage place for memories." A recent memory is that of being awakened around midnight in her third-floor bedroom. She found herself looking into the flashlights of two New York City police officers. The imperturbable Bourgeois was told that neighbors had spotted a prowler breaking a window and that he had now been captured on the first floor. The police apologized for the disturbance, but would she come downstairs and see if she could identify the intruder? She sighed, then murmured, "Let me think about it."

Having lived in the house for thirty years, she asks, "Why should I have been afraid? I've always lived in city houses where you depend on your neighbors." She glances around a room she uses as a salon. It is crammed with photographic archives, stacks of books, a daybed with precarious springs, and a leatherette barstool where she likes to perch. "Besides, there's no money or art here," she adds. "There's nothing valuable," except, of course, Bourgeois herself, and often you can't even find her.

Compulsively, on a mysterious and silent mission, she wanders in and out of a maze of rooms, each with cut-out doors of varying heights, leading to three staircases. From odd angles, the rooms look like an installation ready to be transported to the Robert Miller Gallery, her New York "home" in midtown. She's peering down a spiral staircase; a moment later she's gone. Suddenly she reappears, tapping on the outside of a glass-paned salon door. "I know how to keep out of sight," she remarks enigmatically. "But, you see, I could watch *you*."

The cellar happens to be her favorite part of the house, the ultimate hideout or lair. There, she switches on a bare light bulb that illuminates the pipes, fuse box, and hot-water tank. "Everything that makes the house function starts here," she announces. "If there is a water shortage, if the electricity goes

Femme Maison
c. 1945–47
Oil and ink on canvas
36 x 14 inches
Photo: eeva-inkeri
Private Collection

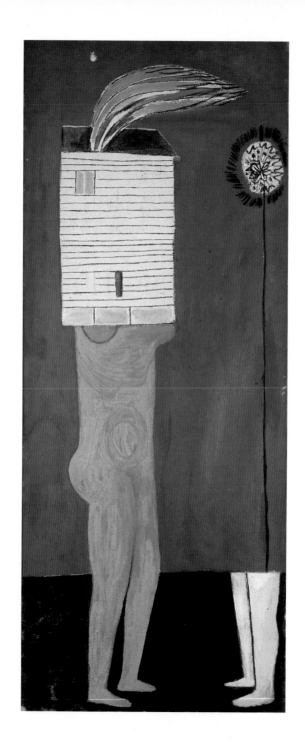

wrong, it takes place here. The basement is the foundation of everything, just as the unconscious is the foundation of your personality."

Seeking another staircase, she ducks beneath a low arch and arrives in the kitchen, the most idiosyncratic room in the life of a *femme-maison*. Bourgeois disdains the concept of an enormous American kitchen. Here is a galley no larger than an apartment foyer. Just as her art tools are kept close at hand, so are her culinary ones. Something seems to be missing. There's no stove. Just a two-burner hot plate and a toaster oven. "Now, the story of the stove," she begins earnestly, like Alice addressing the March Hare. "When my husband passed away in the seventies, I did away with the stove. It was a symbolic action. For if the master of the house isn't here, what is the need of a stove. I once had a big dining table, too. I chopped it up. It's part desk, part table." Her reasoning is perfectly rational. Very Louise Bourgeois.

When she moved from painting into sculpture in the mid-forties, the *Femme-Maison* theme continued with increased psychological meanings. Using white marble thwacked into the voluptuous curves of a mother—a fertility figure sagging with exhaustion, and with only a shrunken dwelling for a head—she produced *Femme-Maison* (1983), an emblematic self-portrait: Bourgeois, late in life. She explored the vulnerability of the empty house or *Maison Fragile* (1978)—merely a steel "roof" supported by four steel legs, not sculpturally fragile at all, but indicating the fragility within the house and an inner emptiness. "My relation to others, not just to my family, is fragile. I'm not very good at relationships," she confides, a delicate pink coloring her cheeks, as she turns away and heads up a staircase without looking back.

After exhibiting paintings, she deliberately chose to make her official entry into the art world as a sculptor in 1949. "I could express much deeper things in three dimensions." For Louise,

Louise Bourgeois

Maisons Fragiles
1978, Steel
One unit:
72$\frac{1}{8}$ x 27 x 14$\frac{1}{4}$ inches
Second unit:
84 x 27$\frac{1}{2}$ x 14$\frac{1}{2}$ inches
Photo: Bruce C. Jones
Courtesy Robert Miller
Gallery, New York.

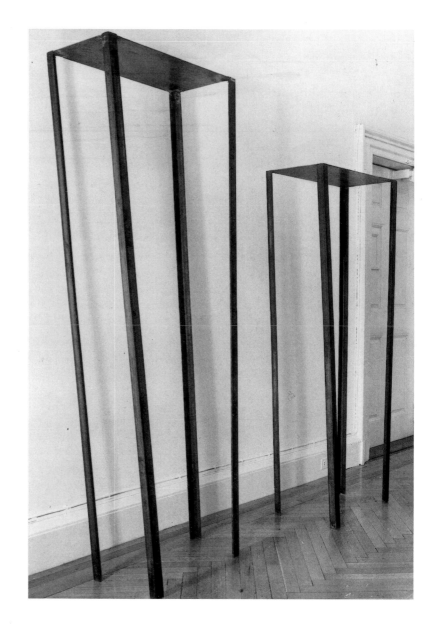

sculpture was the best way to end the struggle between body and mind. Sculpture demanded unconditional surrender. It allowed her to explore private and intimate wishes, fears, dreams. Most importantly, the sexual merging of male and female would later be revealed with a compelling tactile explicitness, even when the explicit is a metaphor.

Announcing her debut, the October issue of *ARTnews*, then published and edited by Alfred M. Frankfurter, reflected the condescending attitude toward women artists with a review of another show by "five European and four American artists and their talented wives." The language of the "Man and Wife" review is gratingly patronizing; it also suggests the reviewer's lack of expectation that the "wives" are capable of creating anything independently of their husbands. Herein lies fascinating social history:

> With the inclusion of several famous husbands — Arp, Ernst, Picasso, Hayter, Nicholson, Delaunay, DeKooning—to name a few, it becomes a study in itself to observe how much or how little the wives have resisted the overpowering influence of their "better halves." It is to the credit of Barbara Hepworth, wife of Ben Nicholson, and Dorothea Tanning, Mrs. Max Ernst, that they have developed a completely individualistic style of their own...

A resourceful art historian named Kevin Eckstrom, on a scholarly sleuth, dug up the critique while studying Bourgeois and the climate in American culture at various points in her development. The word "wife", he noted, becomes "an impersonal, generic term that connotes an occupation in itself, much like Chaucer's Wife of Bath, for whom marriage is a life's work. That the women paint is incidental to their roles as 'wives' in the reviewer's social

construct," argued Eckstrom, who began his exploration as a curator at Washington University's Gallery of Art in St. Louis.

The reviewer sees women artists only in terms of their domestic relationship to men. More social history:

> On the other side of the fence (and in the majority), however, are those wives who, stylistically at least, are tied to their husbands' apron strings. . . there also is a tendency to "tidy up" their husbands' styles. Lee Krasner (Mrs. Jackson Pollock) takes her husband's paints and enamels and changes his unrestrained sweeping lines into prim little squares and triangles; and the late Mrs. Tauber-Arp, wife of Jean Arp, changes her spouse's plastic, asymmetrical forms into neat rows of *Semi-Disks.*

Tied to apron strings, tidy up, prim, neat rows—all the clichéd phrases, continued Eckstrom, established a domestic context for the art and trivialized the women's efforts. Against this background of sexism, which did not change for years, Louise Bourgeois stepped onto the scene. The impact of feminist attitudes on American culture were demonstrated in 1987 when a Bourgeois traveling show, closely watched by Eckstrom, reached Ohio. *The Cincinnati Enquirer* ran the headline: "Works by Women—Bourgeois exhibit like a fine dessert." Not much impact! The headline ignores any rebellious energy, always present in Bourgeois. "A fine dessert"? The provocative nature of her spirals and nature studies would only conjure up "dessert" to a dissolute pastry chef wallowing in the cream of the jest.

Louise's early sculpture—the hand-carved wood *personnages,* made between 1941 and 1953, symbolize friends she left in France,

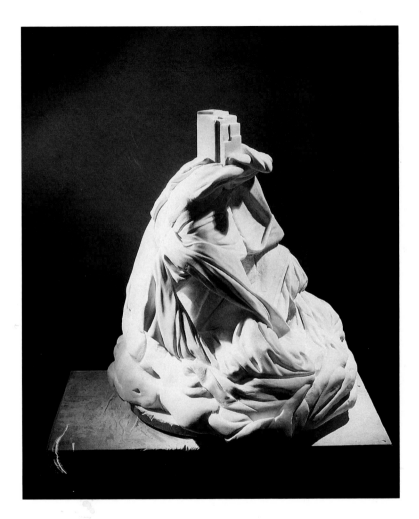

Femme Maison
1983, Marble
25 x 19$^{1}/_{2}$ inches
Photo: Allan Finkelman
Collection of Jean-Louis
Bourgeois

her isolation and efforts, however feeble, to communicate with new friends in New York. "I ran away from people at home, in Paris, because I couldn't stand them, and as soon as I'm away, I start to rebuild them," she has said. The life-size figures in her first two

Louise Bourgeois

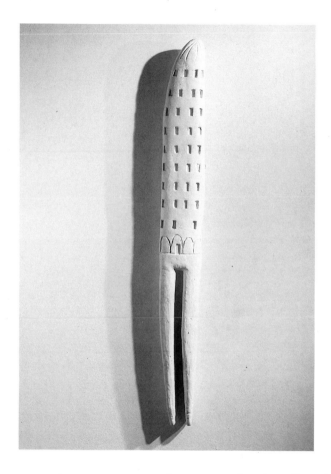

Portrait of Jean-Louis
1947–49
Bronze
35 inches high
Photo: Peter Moore
Courtesy Robert Miller
Gallery, New York

shows—painted black, white, and red—were presented standing alone, as couples, and in groupings. She was one of the first artists to conceive of an installation: you walked into the gallery and encountered a roomful of absent "presences" or ghosts. She recreated the presences to have control of the past.

Her skeletal objects, once described as seeming to "stalk about the room like gigantic matchsticks," are not related to anything tribal or collective; if they seem ritualistic, their meaning is private and the mythology is her own. "It was a reconstruction of the past," she stated. Among her stemmed or polelike figures was "a portable brother—a pole you could carry around. They are presences, portraits, characters," she says, striding up and down the salon, absorbed in thought. "Friendly characters and unfriendly." She pauses. "The one I call *The Portrait of C.Y.* (1947–49)"—an elongated form with two eyes at the top and embedded with a cluster of nails below the heart, if the figure had a heart— "was a person that drove everyone up the wall. I met her in New York. She deserves all the nails I placed in her."

Louise went through a period when her three children appear, singly or together, in different works. *Portrait of Jean-Louis*

Intimacy

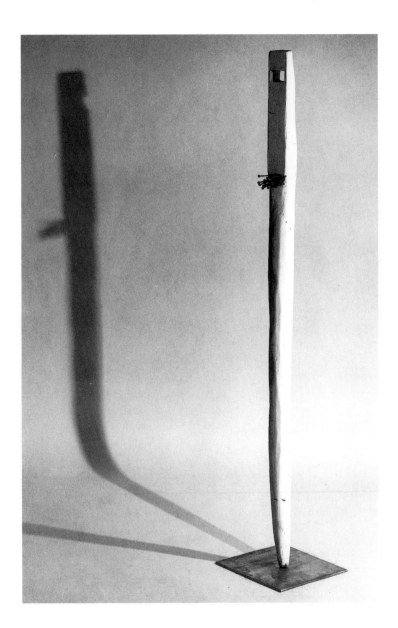

Louise Bourgeois

Dagger Child
1947–49
Painted wood
75 ⅝ x 5 ⅛ x 5 ⅝ inches
Photo: Peter Bellamy
Collection Solomon R.
Guggenheim Museum

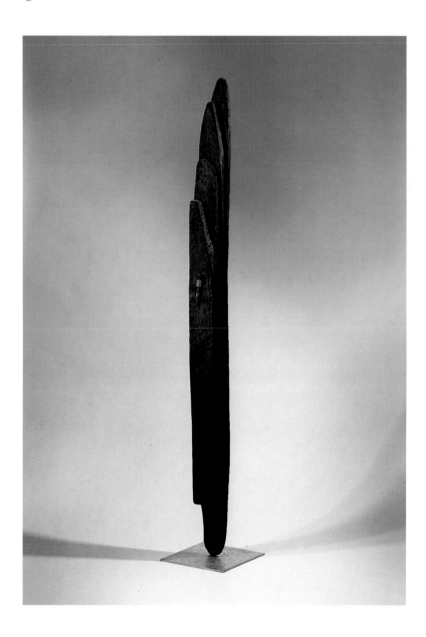

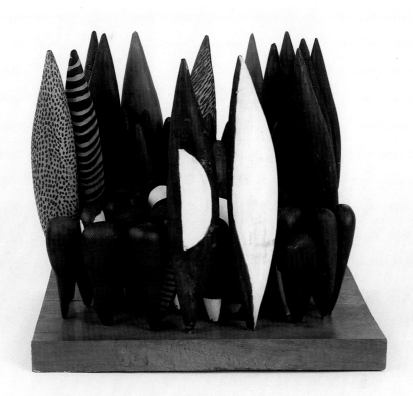

(1947– 49) is an image of a skyscraper, rather phallic, with two legs. "I wanted to do him as a skyscraper because it is a wonderful American structure, it is the character of New York." The early pieces are in wood, she goes on, and though wood is easily trans-portable it is also breakable. "Now, if I was contradicted—and I don't like to be contradicted—I might take a piece and smash it against the table. I explain this because, at the time, I got peeved at Jean-Louis—who remembers why, he was a child. I smashed the

One and Others
1955
Painted and stained wood
18 x 20 $^{1}/_{16}$ x 16 $^{15}/_{16}$ inches
Collection of Whitney
Museum of American
Art, New York
Purchase 56.43

L o u i s e B o u r g e o i s

Quarantania
1947–53
Bronze, white patina
80 1/2 x 27 x
27 inches
Photo: Peter Moore
Courtesy Robert
Miller Gallery,
New York

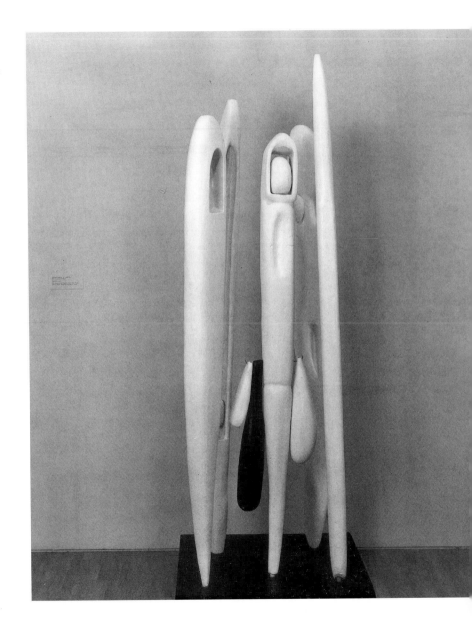

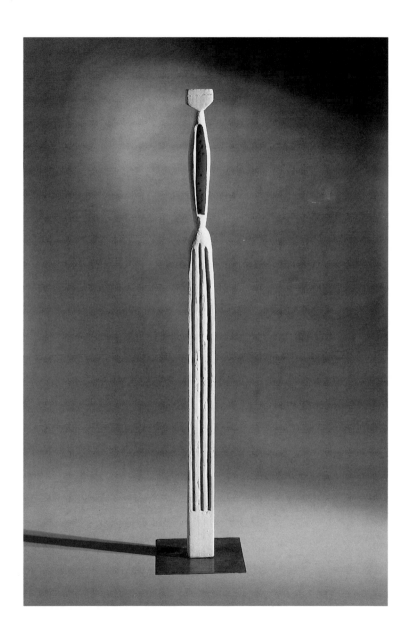

Pillar
1949–50
Painted wood
64 x 3$^{1}/_{2}$ x 2$^{1}/_{2}$ inches
Photo: Allan
Finkelman
Private Collection

piece against the work table. The legs broke. You can see the breakage in the original. So, the sculpture had a real life!" Her sudden laughter is fresh and sweet.

Spring (1949), a longish stem topped with four budding (or flowering) elements, is a happy piece, she explains, but the base comes to a precarious point—a reminder that happiness itself is precarious. The thin, isolated figure of *Persistent Antagonism* (1946–48) is adorned with a kind of wooden necklace or skirt. "The things that hang around you are problems and anxieties that you carry all the time." The threat of pain, of deep wounding, appears in *Dagger Child* (1947–49), in which a small knife is attached to the "presence." She refers to the knife as a little toy but observes that when a mother threatens a child ("If you don't do what I want") the child can hurt the mother. Each can torment the other by withdrawing love. The knife represents violence and aggression. The color symbols throughout her work, from the past up to the present, are constant: white is purity and renewal; blue is peace and escape; black is mourning and guilt. *Dagger Child* is painted black.

Although relationships come unhinged, unbalanced, Bourgeois perceives the need to stand together: determinedly independent, she recognizes dependency. The family, letting go of all defenses, huddles together in *Quarantania* (1947–53). The "presences" in *One and Others* (1955) assume leafy and bulbous shapes as they relate mysteriously. "The little ones can't make it alone, they always need help," she says. Towering over any group in the Bourgeois mythology is *Pillar* (1949–50), a singular and striking portrait of the supporting element in any house that keeps the structure (relationships) intact, especially when a house is disturbed by messy, disruptive emotions and mood swings. *Pillar* keeps life going as usual even when life is not usual.

The opposite of strength is fanciful unpredictability, a person-

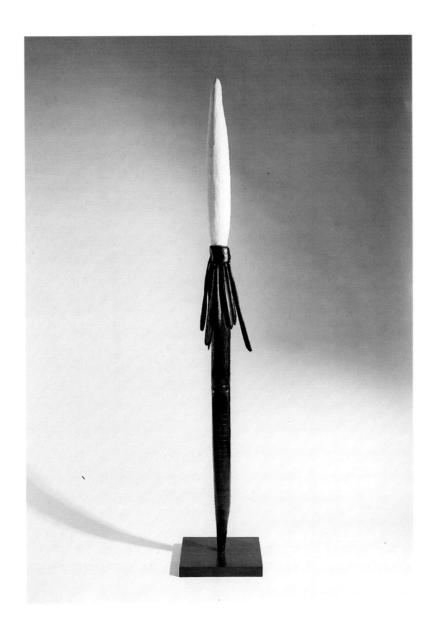

Persistent Antagonism,
1946–48
Bronze
67 inches high
Photo: Peter Bellamy
Courtesy Robert Miller
Gallery, New York

Louise Bourgeois

Dinner Dressing. Scholars and artists gathered at a dinner party (1988), devised by the author, to discuss "Is Food Art?" Bourgeois was her surprising self. During the champagne hour (with Eric Fischl) and the first course of Chinese winter melon soup, she wore a black and white tunic. But when the pheasants arrived she switched to sensuous silk.

Opposite:
"The birds rocking back and forth as if they were alive — now that is a unique idea. It is a form of self-expression," stated Bourgeois, *"and a work of art must express its creator,"* who was Denise Hare.
Courtesy Virginia Liberatore

ality trait Louise appreciates and depicts in *Femme Volage* (Fickle Woman, 1951). A string of wooden "chips," held together on a single rod, are capable of turning or being turned, suggesting woman's active, vital freedom of choice. Refusing to be sheepish or silent, she will move as she chooses. She will do as she chooses. But she always has a strategy for survival, and her strategy involves control.

Feeling a tad reckless and, at the same time, shy, Louise once demonstrated freedom of choice at a singular banquet prepared by the urbane Denise Browne Hare, a world traveler, photographer of art books, and chef extraordinaire. The half-French Denise was enlisted to compose and cook a dinner that would answer the question: is food art? Talleyrand's chef was positive that his gastronomic "art" influenced the French statesman's success. ("Cooking is usually based on a recipe," says Louise, "You can have no recipe with art." Denise Hare concurs: "If you follow a recipe, you're negating the creative act.") Between the serving of Denise Hare's Chinese winter melon soup, accompanied by puff-paste sticks rolled with seaweed and black sesame seeds, and the stunning arrival of boned pheasant breasts covered with their own plumage, Louise took a brief powder. For champagne before dinner and during the first course, she wore a handsome black and white tunic. When she returned to the table she wore a pale purple

blouse. Guests sensed that she looked different but couldn't explain why until they saw photographs of the feast. "I felt a need to make a change, the other blouse was with me, hidden—so, I did it," she admits, "that's all there is to say!"

So much for Bourgeoisian strategy. As for control, she told the English critic Stuart Morgan, who questioned her about private versus public exposure: "When we started talking today I felt that I couldn't go on because my clothes were going to fall off. I said to myself, 'Louise, your clothes are *not* going to fall off,' and I controlled it."

Given her eccentricities and the polarities of personality, the frolicsomeness of *Femme Volage* contrasts with the compulsive and somber stacking of black wood squares in *Memling Dawn* (1951), the title referring to a city by a river. The squares are not evenly stacked. They're on a self-protective lookout, she contends. This work and *The Blind Leading the Blind* (1947–49) are recognized for anticipating Minimalist issues in art. Standing about five-and-a-half feet high, two parallel rows of tapered wooden "legs"—scratchy, tense, unfriendly elements, emotionally detached—are most assuredly attached to a "roof," or shelter of beams. The perilous procession-in-place (painted red and black), creates an uninviting journey that you don't want to hear about or watch. The conclusion to this simple, passive puzzle may be annihilation. Withdraw from the procession, leave it alone. "Fear holds the group together," she says, "they seem to be holding onto each other, they need each other so they won't fall down." A prideful longing to stand alone, although deeply injured, is a poignant dilemma.

Further invention took her into assemblages of vertical spirals composed of sliced, segmented pieces of white-painted wood, or wedges of wood, twisting in space. Though constructed in the early fifties, most were not publicly shown until the early eighties. Her transition from monolithic to segmented work was a conscious move to "articulate" the forms and be more expressive. "The spiral is important to me. It is a twist. As a child, after washing the tapestries in the river, I would turn and twist and wring them with three others or more to wring the water out. Later I would dream of getting rid of my father's mistress. I would do it in my dreams by wringing her neck. The spiral—I *love* the spiral—represents control and freedom." It's also a release from the agony of mind. The spiral pattern evolves into a memorable bronze *Spiral Woman* (1984) who swings freely in space. A coil, a long coil of hair, is wrapped around her. "The woman is naive, she's free, but she

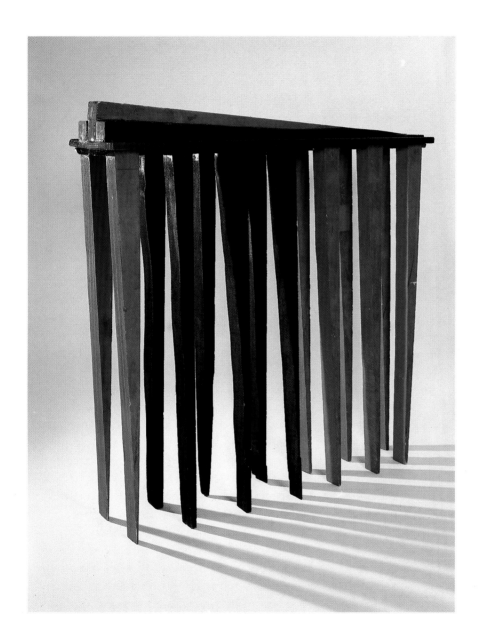

*The Blind
Leading
the Blind*
1947–49
Painted wood
67 $^1/_8$ x 64 $^3/_8$ x
16 $^1/_4$ inches
Photo:
Peter Moore
Becon
Collection
Ltd.

doesn't have a head. We don't see her head because the woman is afraid. She's afraid to look afraid. So she has no face." The happy woman who is afraid? A Louise Bourgeois paradox.

Freedom coupled with helplessness, male dominance contrasted with female nurturing and, then, a role reversal of submission and exaltation—these are some truths of life that Bourgeois faces without flinching. She is never trite. This virtue is also a flaw: without an element of triteness, few works of art can ever have general appeal in a world of mostly mediocre people. Her awareness of individual muddles, her less than genteel absorption with the battle of the sexes and duality of gender, her clinical look at muscle tissues, which women artists preferred to ignore, was fully laid out with her long overdue breakthrough in the early eighties.

There's a quirky irony that Louise, with her honesty, was acclaimed in a decade of greed and cynicism. She became known, she was accepted, but remained on the sidelines of a horrendous circus that saw the junk art of "kiddies" bought with junk bonds. The "new" art of the eighties, much of it influenced by Duchamp and Warhol, was composed of broken crockery, verbiage on boards, recycled toilet seats, broken playpens, rows of drinking glasses, stuffed animals, stacks of cheese boards, teeny-weeny copies of masterworks. In an era of strange folly and cupidity, anything goes— or went. Emerging pristine from the rubble was Louise Bourgeois. She gleamed like a lost treasure, found at last. And yet, she'd always been around, working with quiet intelligence under everyone's nose. Of course, she always distresses those who want "salon" art—art that looks pretty, art that won't disturb the tots. "Brave and consoling," says the free-lance curator Christian Leigh, "Bourgeois's work is like an old difficult friend or relative—they know everything about you and you know everything about them. Their presence embarrasses you, but it makes you feel comfortable and reminds you of how

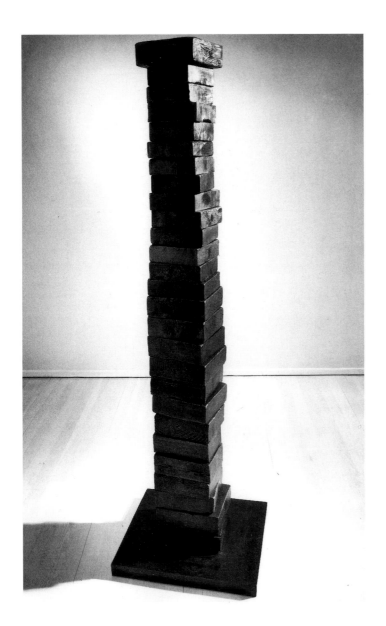

Memling Dawn
1951
Bronze
64 x 15 x 18 inches
Photo: Allan Finkelman
Courtesy Robert Miller
Gallery, New York

Louise Bourgeois

Spiral Woman
1984
Bronze
11 1/2 x 3 1/2 x 4 1/4 inches
Collection of
Elaine and Werner
Dannheisser

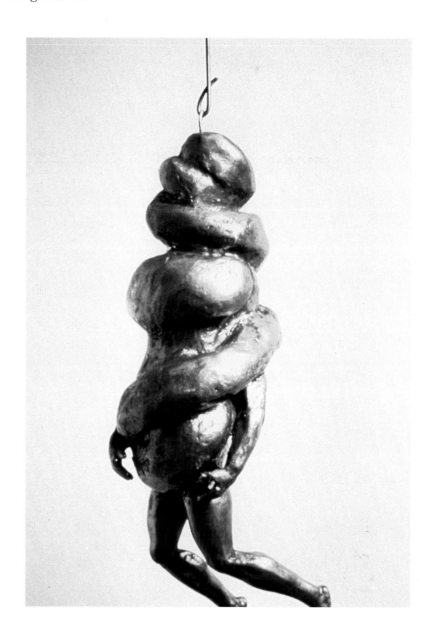

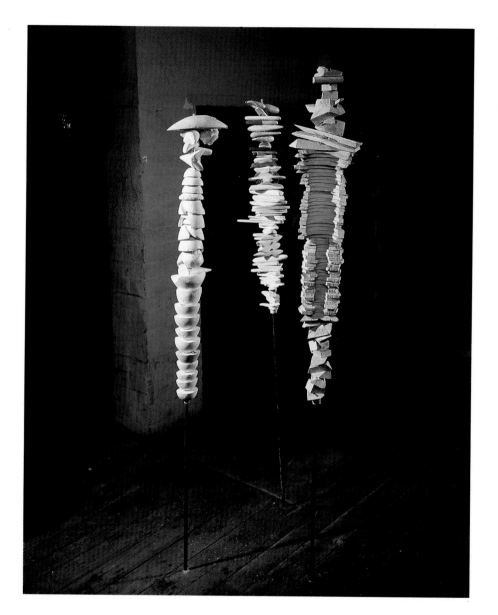

Spiral Women
1950
Photo:
Peter Moore
Courtesy
Robert Miller
Gallery,
New York

you used to feel as well. It makes you warm all over, even if you try to be cold to yourself."

Moving among her undulating shapes and biomorphic forms, ambiguous or androgynous, she asserts, "I want to express an *emotion*. I am asked, 'Louise, why do you use plaster or latex?' The material does not mean much to me. It is just a means to an end. Some artists are afraid of emotion. I am not. Edvard Munch was a revelation to me, and this was a great mystery. So I had to find out why. I could not let go. You see, I felt I was Munch and he was like another Louise. I realized that we shared the same intensity and anxiety. This, I thought, was very strange and also pleasurable. I also fell under the magic and, therefore, the mystery of Francis Bacon's work. His emotion is overriding. It transforms, manipulates, and twists things around. Emotion is always difficult to understand. But I am mesmerized by it."

Admittedly, she finds more freedom with assembled or poured materials than with stone. "Marble has a softness of tone and hardness of substance," Henry James observed, and "isn't that the sum of the artist's desire?" Marble also has purity and luster. "Feel it, touch it, caress the work," she murmurs on another day in her Brooklyn studio. "That piece of marble is beautiful." The stone came from Italy and sat in the studio, like a block of unmeltable ice, waiting for something to happen. For a long time nothing did. Bourgeois wrestled mentally with the marble, envisioning various concepts. She drew no sketches. She arrived on a wintry morning "feeling very aggressive, ready to get at it," her eyes shielded by goggles, electric drills whirring. "At first I wondered if it was possible to cut through the stone or if it would crumble. But when I hit it with my hammer it vibrated as a whole unit and I knew it was fine. Sometimes a stone is defined by its flaws." She leans on the white marble and adds meditatively, "This is true of people, too."

With the help of an assistant, she is drilling intersecting passages, explaining that it's an outdoor piece: when the sun is high, it will light the marble from within. Usually she begins by hammering the outside of a stone, but this time she started by plunging straight *into* the marble. "When you begin from within, you're an adult, you have confidence. Starting from outside you're like a child wandering around a world you're trying to discover."

At one point, a discreet slit is added to the far side of the marble. "Sexual? If that's what you see, you are projecting your own psyche into the work." She is adamant that all her works—whatever they seem to resemble—are abstractions. She calls this piece *The Sail* because the curve on the side of the marble has the sweep of a sail on a boat when the wind pushes it. Then she repeats her claim: "I am never literal, never realistic. What we see is very abstract." She peers into the piece from the top. "The passage here refers to the biblical quotation about a camel passing through the eye of the needle. André Gide calls it *la porte étroite* —the narrow door. Gide lived in puritanical hell. He equated his suffering and sense of guilt with the difficulty of entering the narrow door or the 'eye,' a metaphor about how we find redemption. Just as there is a compulsion that keeps me working on this piece, a rite of passage that I go through, the subject itself is the rite of passage. For the artist, it has pessimistic overtones. He tries to become an adult. But the artist never loses his innocence—that's what makes him an artist. He expresses what others are terrified of. In his innocence the artist reveals things about himself that others would keep quiet."

Sculpture gives Louise permission to "reveal" anything, although the image may prickle others. Her relevatory *innocence* held up acceptance in the sixties when many people were still unable to talk openly about sexual fantasies displayed in galleries. And, as Louise left her wooden "presences" and began exploring

landscapes of the body in various configurations, her personal visions were too intimate and disturbing.

Other sculptors in the male-dominated art world explored geometric forms, unadorned industrial surfaces, neon light tubing, Cubist constructions, and mechanical intricacies of hulking sculpture that had no content. When a savvy collector of contemporary art, hoping to buy a Bourgeois, visited her studio and confronted pendulous objects that look remarkably like sexual organs, she gasped to an accompanying advisor, "My God! How could I explain this to my children?" Catching her breath she then considered, "How could I explain this to my husband?"

From the womblike structures that start Louise's continuing *Lair* series in the sixties to the symbolism of today, she is always redefining motifs; her imagery keeps evolving as she rediscovers her vision. In her earliest drawings and paintings rolling hills become breasts and phalluses; breasts become spirals; spirals meld into eyes. The contours transform themselves. And it's not just "tits and cocks" as the collector said on leaving her studio with an embarrassed aplomb. Louise would have applauded her use of language, though not the accuracy of the remark.

For years art writers pussy-footed around the imagery, wheezing about "the life force" and "nourishing" aspects of some swollen, rounded, and otherwise bulbous concepts. Eventually the erudite would make allusions to the Venus of Willendorf and the multi-breasted Artemis of Ephesus to explain or legitimize their unblushing praise. It is comical to imagine Louise reading the critiques while forking a chocolate tarte and wearily thinking, aloud: "Well, it doesn't really matter, there's so *much* to do." And if writers are oblique, it's because editors are squeamish and so are museum curators. Rarely do her traveling exhibits in the United States contain anything treacherously expressive. The critic Rosalind Krauss

chides that nowhere in the literature on Bourgeois is there an admission that, sooner or later, you're "face to face with the reality of organs." Bourgeois is mindful of puritanical neuroses and the troubles they can produce. "I have a dissatisfaction with my own body," she says simply. "It's not as beautiful as I'd like it to be. Sometimes you're in the company of someone who pleases you, and there's a desire to make this pleasure palpable and visible to others. So I have done nature studies that recall a friendliness of the body and its hospitable aspects."

She welcomes the bold confrontation. In *Trani Episode* (1971–72) interlocking abstract forms, vividly filled with "the life force" —semen/milk—rest atop each other. One of the nestling forms has a nipple on the end, making the piece male-female. The bronze *Janus Fleuri* (1968) dares the viewer to confront a vagina superimposed—or lavishly draped—over suspended testicles, hanging, vulnerable, from a hook. The image is blunt and angry, even repellent. Both works express again the passive-active, with a yielding to power and loss of control that must accompany intimacy, that goes hand in hand with the pleasure of intimacy. She is fond of the cumulus cloud formation—dense, white, rounded. *Cumul 1* (1969) presents a cluster of engaging "clouds": phallic breasts. Glancing at them, she laughs quietly, a soft, intimate laugh, and then stops. As an intimist she learned long ago that pleasure repeated too often numbs the pleasure.

Louise once thought her clothes were going to fall off. Perfectly natural. Why not? The expressive life of the self, as she says, involves nakedness—a sexual self-baring that, creatively, opens a private universe. The philosopher-poet Georges Bataille writes, "As often as not it seems to be assumed that man has his being independently of his passions. I affirm that we must never imagine existence except in terms of these passions." For Bataille, "In human consciousness eroticism is that within man which calls

Louise Bourgeois

Trani Episode
1971–72
Plaster and latex
16 ¹/₂ x 23 ¹/₈ x 23 ¹/₄ inches
Photo: Peter Moore,
Courtesy Robert Miller Gallery, New York

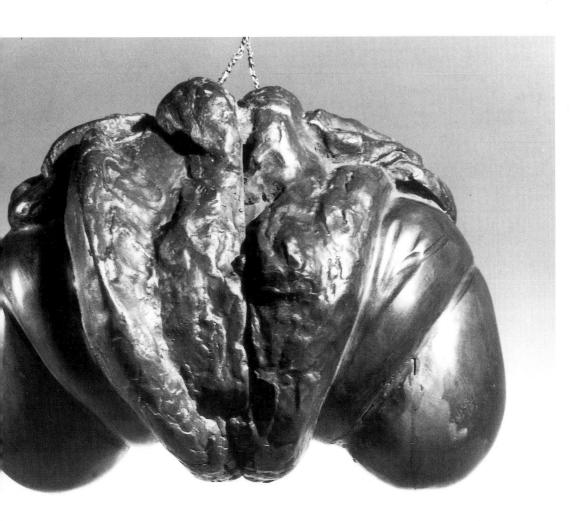

Janus Fleuri
1968
Bronze, golden patina
10⅛ x 12½ x 8⅜ inches
Photo: Allan Finkelman
Courtesy Robert Miller Gallery, New York

his being into question." And for Bourgeois, her being is called into question by herself.

"I'm so inhibited at the reality level that the eroticism is completely unconscious," she once stated. She then recalled student days in Paris at the Ecole des Beaux-Arts. "We had a nude male model. One day he looked around and saw a woman student and suddenly he had an erection. I was shocked. Then I thought, what a fantastic thing, to reveal your vulnerability, to be so publicly exposed! We are all vulnerable in some way, and we are all male-female."

Some pious popinjays still chirp that art should uplift and ennoble and induce spiritual exaltation. The truth is that the inspirational value of art has become a proverb, a phrase for promiscuous mouthing, observed the cultural gadfly George Jean Nathan. "What, precisely, is the ennobling nature of *Macbeth*, Rembrandt's portrait of his sister, *Madame Bovary* or Richard Strauss' *Salome?*" Great Art? He believed it should jeer at us and challenge us. It should sting to the quick.

Proceed with caution. Everyone who paints or sculpts wants to be called Artist when the appropriate word should be Artisan. Novelists, for example, do not have the temerity to call themselves Artists. Yet no one disputes the chasm between Anita Brookner and Danielle Steel. Most painters and sculptors, often in the most glossy galleries, belong to the School of Steel. For discerning the genuine article, you can't trust dealers or art advisors. You have to trust yourself, which few have the courage to do. But the expressive life of the self also involves a mind that enjoys unraveling the radical aesthetic mysteries, the mysteries that Louise Bourgeois tries to solve.

For art, if it deals with life at all, must do so by symbols. It cannot be a replay of misery headlines. Its objective is not some

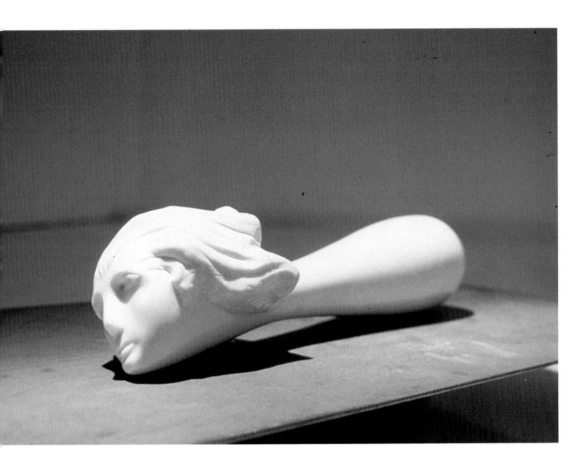

Fallen Woman
1981
Marble
$3^{3}/_{4}$ x 4 x $13^{1}/_{2}$ inches

notion of reality but, as seen in the work of Bourgeois, the truths of living. There is no *comédie humaine* with Bourgeois. Hers is a mix of mythology and an inhuman comedy of dangerous secrets, fantasies in friction, and grotesque memories.

S ome of her most striking, accessible work, where the symbol of survival stares into the abyss beyond desire, carries a sharpened sensuousness. Her *Femme-Couteau* (Knife-Woman) series, which was first shown in 1969, depicts the seductive body of a woman that slowly turns itself into an elongated knife. These small figural pieces are made of white, black, and pink marble (pink, she says, means that you like yourself). The series represents the polarity of women, the destructive and the seductive. "It symbolizes women who are afraid of men — so they imitate men, or, to protect themselves, they turn into a blade. But when the woman becomes aggressive, she also becomes terribly afraid. There is always the love-hate element."

Fallen Woman (1981), another legless, armless woman whose body is shaped like a bowling pin, has a delicately carved face — a kind of self-portrait. The features are astonishingly clear. "I needed a very tiny chisel, especially for the eyes. The only place I could find the chisel I needed was in a dental supply store." *Fallen Woman* is an object of tenderness, longing, and compassion. The beauty cannot stand up. She is utterly helpless. Louise cuts to the core: "You want to protect her. She's beautiful. But because she cannot stand, she has no purpose." Then in a remote half-dreaming voice she glides on, "People appreciate her in her youth. She doesn't know this. She feels she has no sense of worth. She never knew that she was beautiful."

Climbing around on the jagged slopes of her psyche, Bourgeois, always taking risks, creates only to please herself, so why not defy nature? Her bronze *Nature Study* (1984) is a headless animal, a freaky savage in a crouching position with two sets of fleshy breasts, a double set of paws, and a male organ. Nature's way is a merger of sado-masochistic craving: domination and diminution of the ego. But is this the depleted mother or a beast, demanding to be worshiped, whose body is equipped for endless gratification and commands it? The work is like a "hhurrrry, hurrrrry" attraction at a carnival that offers the bearded lady and the Wild Man of Borneo with a hook passed through his tongue. "Step on up," cajoles the barker, "are you afraid of touching my little beauty, *touch it.*"

Nature takes an even darker swerve in the black marble *The She-Fox* (1985), a crouching frontal figure with four breasts. To some it suggests a fertility goddess who has (it is assumed) female genitals instead of a face. Viewing the tortured thing, Louise, whose own nature is not easy to perceive, shakes her head no. The headless creature, with a gash on its neck, is a woman whose head has been cut off and whose throat is slit. The woman represents her mother. "Not the way she was but the way I perceived her until recently," she has explained. "She has gone through quite a lot. But she is still standing because she is eternal."

Nestled between the knee and left paw is the small head of her *Fallen Woman*. The inset with the face of little Alice, a face that only wants to be loved, is a self-portrait, and she is happy because she's protected. Louise never shirks a good fight, and the resisting marble gives her one. *The She-Fox* has been struck over and over again with a pointed chisel, giving it a scarred finish. The little face is gleamingly smooth. The "mother's" surface has taken all the whacks and thwacks because a mother can take anything, she says. "This is the definition of a parent. You have to be a saint

Louise Bourgeois

Nature Study
1984
Bronze, polished patina
30 x 19 x 15 inches
Photo: Allan
Finkelman
Collection of the
Whitney Museum
of American Art, New
York Purchase, with
funds from the Painting
and Sculpture
Committee, 84.42

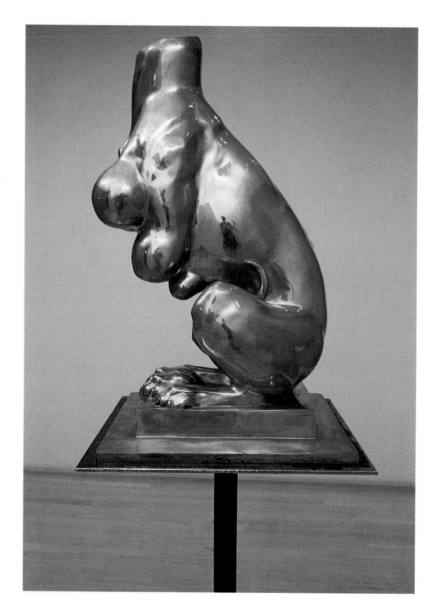

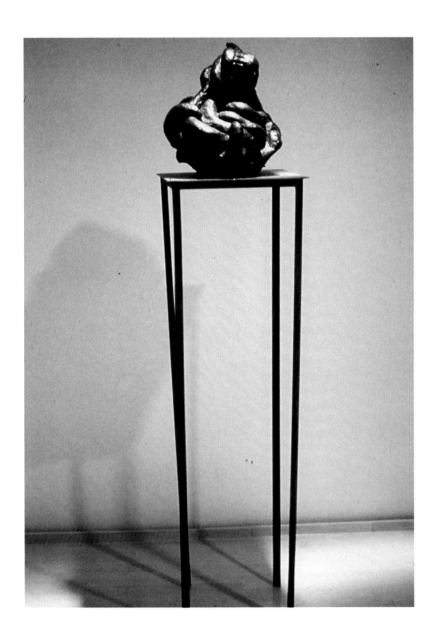

Nature Study
1986
Bronze
11 x 18 x 13 inches

Louise Bourgeois

The She-Fox
1985
Black marble
70$^1/_2$ x 27 x
32 inches
overall
Photo:
Peter Bellamy
Oliver-
Hoffman
Collection.
Promised
gift to the
Museum
of Contem-
porary Art,
Chicago

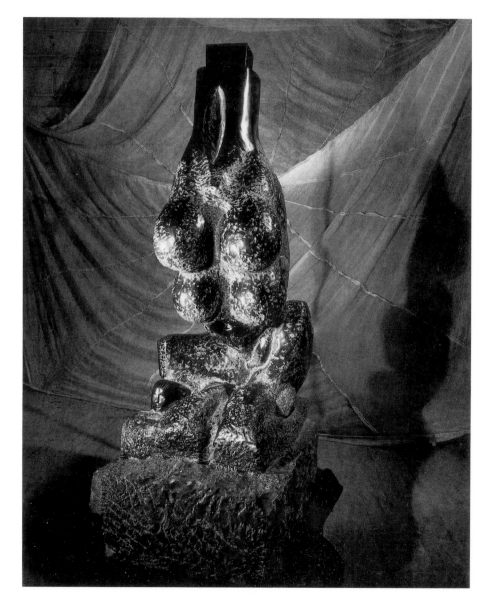

to be a parent." And sometimes you have to be a saint to be the child of a parent. Louise knows all about that, too.

Can nothing preserve the fragile family from splitting apart? Perhaps a pacifying hand. The tender hand of an adult (presumably) reaches out to calm a hapless, troubled being, represented by encircling coils or an umbilical cord in her bronze *Nature Study* (1986). The work is purposefully ambiguous. She has proposed that it might be the hand of a little god or another self-portrait. Since the configuration is decidedly intimate, it could also be a masturbatory hand seeking momentary release—and relief—from all family relationships.

At an award ceremony Robert Storr, a curator at the Museum of Modern Art, reminded an animated crowd, "Though she is not exactly the average person, what makes her exceptional is not her lack of familiarity with the complexities of domestic life but the opposite. She is, in fact, an expert in 'family values.' Having endured paternal love as a kind of Chinese torture and experienced maternal love, as she says, on a 'ferocious level,' Louise has come to us to report that all is not well in the best of all possible worlds, or in the most perfect of nuclear families."

Some years earlier, her environment, *The Destruction of the Father* (1974) was a ghoulish statement on the family, her childhood in Paris with its stresses and pressures—as she remembered it. "What is important to me is *the recall*," she insists anew one afternoon walking through the flower stalls of Chelsea, past potted ferns and plants that take on Bourgeoisian shapes—sprouting, tangled leaves that could be skeins of wool or strands of hair seen in her drawings; spiraling branches of trees with lemons that seem like body parts; long-stemmed tulips, camellias, violets, and rose bushes. "Recall is a scientific word," she continues. "I allow myself controlled recall. I can say what I feel, what I recall. The fight is a kind of articulation. When it is successful, I am liberated." She recalls

that for years she was teased by her father. "Teasing, you see, is a permissive form of cruelty." Attempting to exorcise the past, she built an anatomical structure in latex and plaster—a claustrophobic, cavernous chamber in which soft, bulbous forms hung from the ceiling and surrounded dismembered limbs, the leftovers from a cannibalistic ritual. *Destruction*, which is alternately titled *The Evening Meal*, is a menacing installation that lets viewers witness the end of a violent act. "At evening supper," she says gravely, "the father is eaten up by the children." Then she pauses to smell a bunch of red roses. She wears an innocent, delighted smile.

From the fantasy of revenge *à table* she went directly into the theater of the absurd. Despite anxiety tears before the opening, she was aglow when another, far more bewildering environment, *Confrontation* (1978) was put on. Bourgeois believes absolutely in the meaning of a confrontation. "You cannot always sit quietly," she says, with an air of vehemence. "Sometimes it is necessary to make a confrontation"—she clasps her hands—"and I like that." With Bourgeois around, you never know when a confrontation might unexpectedly arise. Once, following a private screening of the film she is shooting (the unedited footage now exceeds that of *Potemkin* and *All Quiet on the Western Front*), she repaired with her guests—a scientist known as the Viceroy of bulimia; a theater director; and his sidekick—to a downtown club for celebratory drinks. The problem is that Louise's consumption of spirits seldom exceeds a thimble of wine. Drinking, she feels, lessens the control. The previous day, after a tidge of sherry, she upbraided a writer: "You get me drunk and I say things I shouldn't." Frigidly advised that two sips could not make her tight or tanked, she demurred but hastily amended: "*Bien.* You make me say things I shouldn't," and went in search of club soda. Bourgeois always knows precisely what she's saying—and doing —otherwise there'd never be any confrontations.

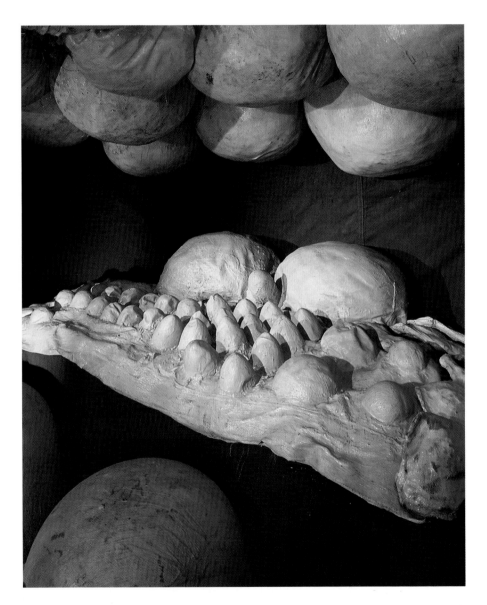

The Destruction of the Father 1974 Latex, plaster, and mixed media 93⅝ x142⅝ x 97⅞ inches. Photo: Peter Moore Courtesy Robert Miller Gallery, New York

Seated at a round table the group ordered a bottle of Pouilly-Fuisée and toasted Bourgeois on her candid camera. The theater director spotted the actress Sylvia Miles a few tables away and nodded hello.

"Do you know her?" Louise asked.
"Not really," he answered.
"But you have talked with her," she cross-examined.
"Naturally."
"Then invite her to our table."
"I don't think so, Louise, she's occu—."
"Aaah," she interrupted. "I see. You're afraid to invite her. "
"I am not afraid."
"Then bring her to our table."
"*I don't want to.*"

"So," Bourgeois said, drawing herself up like the inimitable Margaret Dumont after being insulted by Groucho Marx ("Did anyone ever tell you you look like the Prince of Wales? And believe me when I say whales, I mean whales. I know a whale when I see one.") Bourgeois was stirring up a whale of a confrontation. And loving it. The two argued back and forth. Absently fingering her wine glass, she swallowed a drop or two. Then she turned to the Viceroy and commanded: "*You* invite her to the table." Terrorized by her forcefulness, he dutifully asked the surprised Sylvia Miles to pop over for a chat.

Bourgeois leaned back triumphantly. The show was on! Greetings were exchanged and the dazed director, as if finding himself in cloud coo-koo land, with resistance conquered, heard himself say, "I'd like you to meet Louise Bourgeois." The social amenities didn't matter to Louise. She didn't see herself as a *presence* to be introduced, she didn't even want her name mentioned.

In those days she hadn't been photographed and paragraphed. She ambled around town almost anonymously. Friends said she was a perfect little darling— until she felt like having a confrontation.

"Hello," said Sylvia Miles with the warmth of buttered toast. Then turning to the director who runs a theater in Delaware, she fixed her eyes rigidly on him. "I'd like to do *The Milk Train Doesn't Stop Here Anymore* at your theater," she said without any shilly-shallying around. "Tenn says I'd be his choice for Flora Goforth." In the apocalyptic drama by Tennessee Williams, the debauched Mrs. Goforth meets the Angel of Death in her villa on Capri, or something like that. Sylvia produced a letter, postmarked Key West, in which the playwright lauded her talents. "He signs his letters '10,'" Sylvia explained as Louise puzzled over the numerical signature. "I see," she answered cryptically. Putting the letter back in her purse, Sylvia returned exclusively to the director who was unprepared for instant deals. Her bosom heaved with the volcanic fire of the Italian riviera. The director was unmoved. The Viceroy lost possession of his senses. "Hey, this is a great idea," vouched the sidekick. Passion spent, Sylvia excused herself with a last utterance: "Remember Goforth." Everyone sat tongue-tied, even Bourgeois. Then, in a hushed voice she ventured, "Go forth? What does this mean? It is very interesting, I think."

"Do you really want an answer," someone asked.

"No," Louise snapped, making it the shortest "No" ever spoken.

The confrontation was over and Bourgeois declared that she had enjoyed herself immensely. Her group was slightly fuddled.

"Louise, you're impossible," said the director's friend with mock severity.

"Yes. I can be impossible," she answered brightly. "That is why I like the confrontation. But the confrontation does not always mean you are combative. It covers many emotions."

Louise Bourgeois

Confrontation
1978
Painted wood,
latex, and fabric
444 x 240 inches, variable, 37 x 20 feet wide
Photo: Peter Moore,
Collection Solomon R.
Guggenheim Museum

Now, many years later, Bourgeois occasionally asks about theater director, and so does Sylvia Miles. No one forgot the confrontation. It was a real-life comic event that Bourgeois orchestrated just as her environmental *Confrontation* was a tragi-comic piece that she constructed.

Disquieting in its allusion to a debauch of consumption and copulation that leads to a confrontation with death, the work's centerpiece was a kind of banquet table heaped with latex goodies—an orgiastic feast of the organs, or perhaps, a carcass or two (male-female) from a ritual sacrifice. Surrounding the table were low wooden boxes of varying sizes, shapes, and angles. The boxes, she has stated, represent coffins, a reminder of how short life is.

"The forms on the table represent an old and young human being." There follows a dramatic pause worthy of the Divine Sarah when she dared to play *Hamlet*. "The two are dead. The only resolution is in death." That formidable line occurred only moments before she shifted the mood upside down, inside out, and staged a happening within the brooding installation. She calls her gallery event *A Banquet/A Fashion Show of Body Parts*. Fascinated by "punk"—a threatening stance in clothes and clipped coiffures that mercilessly parodies the bland fifties—she presented a nervy hour of satiric fancy. Punk models, barely clad in form-fitting latex, shouted verbal abuse at one another and showed off in public some enormous private parts created by Bourgeois, who watched with maternal glee as her motley crew—students, designers, art scholars—obediently strutted around the banquet table. The spectators—a Who's Still Who in the art world—either sat or stood in the wooden boxes. "Of course they did not know they were in *coffins*," she

Privates on Parade. "The Confrontation" exhibit (1978). The art world, always seeking an Event, turned out *en masse* for her staging of "A Banquet/A Fashion Show of Body Parts." Along with her punk models, art historian Gert Schiff, in a Bourgeois costume, struts his stuff. Bourgeois (upper left) is having a whale of a time.
"It was all a joke, a comment on the sexes because they are so mixed today."
Courtesy Peter Moore

later confided with selfless rapture. The performance over, the worldly riffraff gone, Louise said musically, "But, you see, it was all a joke, a comment on the sexes. What more is there to say? The humor is black. Despair is always black."

Intrigued by the immediacy of the theater and its direct confrontation with performers whose sexuality and physicality can be used to express narrative art, her life-and-death theme was further explored in *She Lost It* (1992) at the Fabric Workshop in Philadelphia. But this time her vision was muted and melancholy. The fable, written in the forties, was of separation and loss and bruises that must be suffered. Her fabric choice was a cotton gauze —the material used for covering wounds. One performer, tightly wrapped in the gauze like a mummy slowly turned round and round while the gauze— imprinted with a short text about a woman waiting for a man to return home—was rewound around an entwined couple. Watching the performance later on tape, she explains, "The story of separation becomes an act of binding the couple together." Then she observes, "The boy and the girl who are a bound couple, as close as two peas in a pod, are not attracted to each other. They're just kids in the workshop. But *I* am attracted to the reality of what is going on." Embroidered on the underwear of the performers, when fully seen, are her lifelong contemplations: "I had to make myself be forgiven for being a girl" and "Fear makes the world go round." Unlike the fleshly bite of her fashion show, a strange sadness hangs over the project. Bourgeois has confronted psychic and physical wounds without making a sound.

And she is always there, peeping through curtains, half-shuttered windows, parted drapes, an opened door—voyeur and voyager —as she absorbs contradictions and distortions of indecent dimension. She refuses to shut her eyes: the chimeric apparitions give her strength. She is beyond the grasp of her parents and she can tell any phantom, "You see, I'm alive—I enjoy the unspeak-

able." The surrealism and hyper-realism in the films of David Lynch, where the suburban cottage conceals something terrible, give her pleasure. Her favorite is *Eraserhead*. "He's the one movie director I'd like to meet," she says. Lynch started out as an artist. The imagery in his film *Blue Velvet* assaults the viewer with ordinary-appearing fragments that dissolve into nauseating reality. A father's heart attack is followed by a preppie youth coming upon what looks like a severed ear in the grass. It *is* a severed ear, swarming with ants. "There's always more than meets the eye," says Bourgeois, who collects scraps of evidence with unwavering eyes.

E yes, another body part, mysterious protuberances, holes, slits in the face, organs with a life of their own, appear in drawings and a startling series of giant marble eyes that mutate into breasts, a sexual opening, a lair-hideaway. Skeptical eyes, she observes, clear away the blindness of dogma. Her seemingly floating eyes—perverse, playful—carry the phantasmagoric sensibility of a Roald Dahl creation whose short story *William and Mary* puts him eye to eye, as it were, with his surreal imagination. In his fable the terminally ill William agrees to an experimental operation: his valuable brain will survive floating in a special fluid and connected to one eye also floating on the surface of the liquid. He will live in a pure and detached world without pain, fear, frustration, or desire. "I may actually see you again later," he tells his wife Mary. The operation is a success. Mary finds his eye, the size of a pigeon's egg, watching her with peculiar intensity. No more rules, arguments, criticisms, she thinks, pleased to have her husband in a basin. And, no more orders not to smoke! She lights a cigarette and exhales, whooosh, causing a blue

Louise Bourgeois

Photo courtesy Duane
Michals. This photo
was originally published
in *Vogue*.

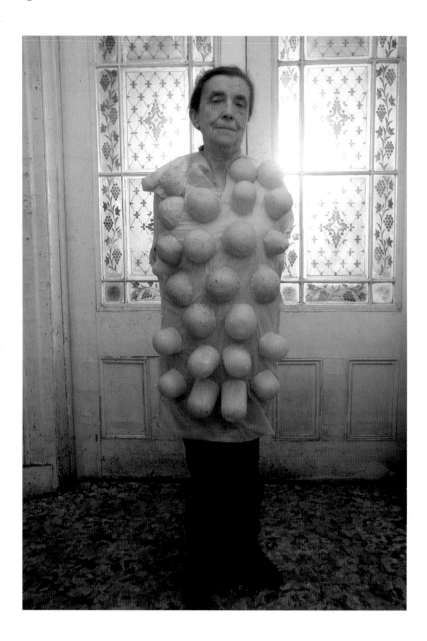

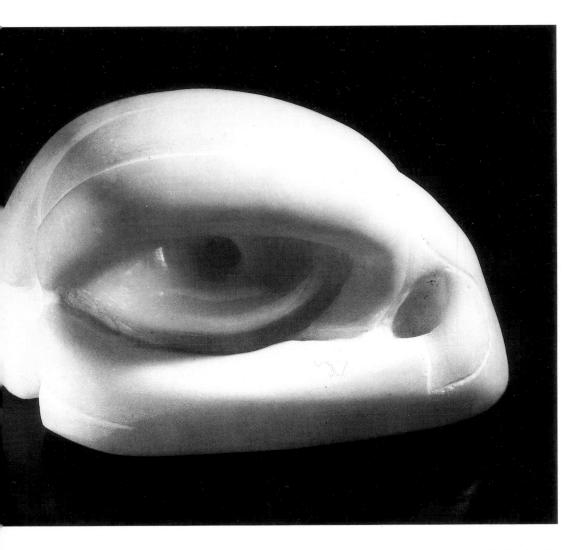

Bald Eagle, 1986
White marble
4 1/8 x 7 x 5 1/2 inches
Photo: Allan Finkelman,
Collection of John Cheim

cloud to envelope the Eye. She can hardly wait to get him home. The Eye flashes in fury. The eye is a powerfully suggestive image. As a presence it remains insistently visible after the surrounding content is taken away. Of her "floating" marble eye *Bald Eagle* (1986), which could easily be William, Bourgeois says: "Eyes never lie. That's why they are so important. We can lie with words."

Personal relationships, formal relationships haunted Bourgeois and she's too smart to believe surface answers about them. She accepts all aspects of character, including her own, while trying to make sense in her art of what is elusive in life. Never attached to any "movement" (though "solidarity in the women's movement is very dear to me," she declared in the seventies), she has further declined to attach herself to "the cause" of the day, which many artists use as an excuse for self-indulgence and a gimmick to grab attention. She does, however, vent her feelings on hot political questions and is appalled that batty lumpkins would still deprive women of equal status, particularly in relation to their own bodies. And the Vietnam War did not pass unnoticed.

Instead of making a "topical" work that dates as quickly as the daily newspaper, she expressed herself within her stylistic vocabulary, using abstract elements as familiar as the spiral or the eye. *The No March* (1972) is an environmental piece composed of hundreds of small white marble cylinders massed together, their tops sliced off at slanted angles and placed on the ground. The assemblage of marbles, a large-scale reminder of her early *personnages*, independent figures in a landscape but now a dependent, lonely crowd, was made during the Vietnam War. It is a reference to a peaceful march, a non-violent protest. Courage transcends muscle.

Acquired by the Storm King Art Center, a 400-acre outdoor sculpture park in Mountainville, New York, *The No March* was arranged on a lushly planted green amid the gently rolling hills of

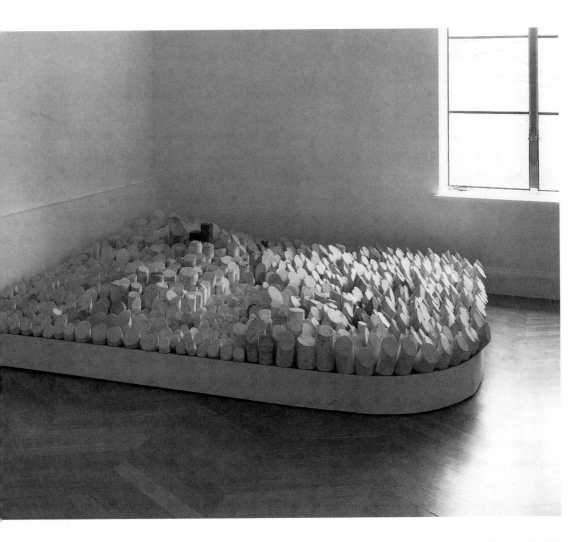

Number Seventy-Two (The No March), 1972
White carrara marble, pink Portuguese marble, black Swedish marble, travertine
10 x 204 x 120 inches, Photo: Jerry L. Thompson,
Storm King Art Center, Mountainville, NY. Purchased with the aid of funds from the
National Endowment for the Arts and Gift of the Ralph E. Ogden Foundation 1978.2.

the Hudson River Valley. Truly an original, the Bourgeois quietly dominated the 120 other—mostly monumental—works by famous names. Acting like a field magnet, it dazzled visitors unable to resist stealing the small marble cylinders that seem to breathe with a destiny of their own. To halt the disappearance of the "marchers," Storm King moved the piece into the museum building itself. Though less visible now to public eyes, like the Noguchi or Calder, Bourgeois's social grouping bursts with personality, each cylinder an observant individual. "*The No March* also means accepting you're almost nobody," says Bourgeois. "You have to merge with thousands like you. This is a passive thing. Whereas the finding of yourself is active, and you must realize that road is very solitary. You walk alone."

But when the straggler is alone, the need for security is momentous. "When you experience pain, you can withdraw and protect yourself," says Bourgeois, commenting on her *Lairs*, first exhibited in 1964. The segmented work had led naturally to coils and spirals of her early mysterious lairs. "The lair is for seclusion and rest. But the security of the lair can also be a trap." Some of her lairs, made from plaster, latex, and rubber, resemble shells, scatalogical labyrinths, and may hang suspended like pendulous nests. Aware of furry and winged animals that burrow into secret retreats, Bourgeois finds the lair essential to staying alive.

Articulated Lair (1986), an environment of metal shutters, forms a circular 13-foot-high folding screen around a low stool. Hanging rubber forms—pendulous "presences"—inhabit this lair. They are uneasy reminders of possible intruders. A flexible space that can be made smaller or larger, the lair has two doors: an entrance, an exit. "I can escape. I can watch who is coming. I can recover here. It is beautiful, peaceful." Smaller lairs, or rather cells, are composed of five wooden panels, about seven feet high. The panels are discarded doors now hinged together and can be opened

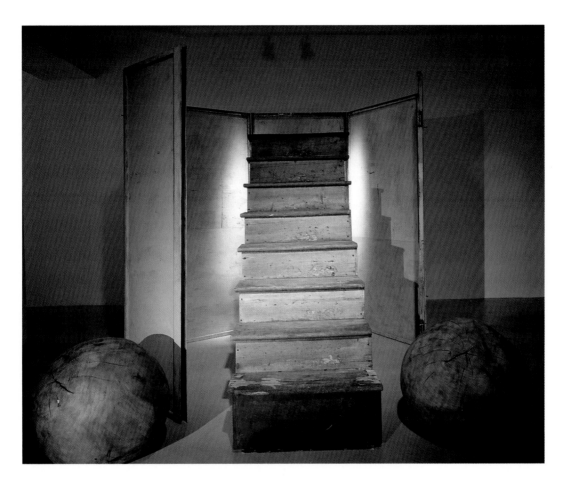

No Exit
1989
Wood, painted
metal, and rubber
82$^{1}/_{2}$ x 84 x 96 inches
Photo: Peter Bellamy,
Ginny Williams Family
Foundation, Denver

Louise Bourgeois

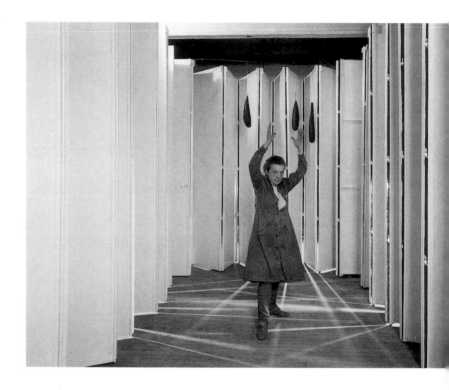

or closed. The five panels represent her family in France. Coincidentally, her marriage produced a family of five. The panels are painted blue. A refuge from all outsiders, the space is protection against falling in love, against being punished or abandoned. And finally, she says firmly, sitting on a stool, hands folded in her lap, "It is about the right to shut the door!"

Related to the lair are two terrifying enclosures: *No Escape* and *No Exit* (1989). Darkened, enigmatic chambers, the two highly theatrical works present steep wooden staircases that go nowhere. They are partially surrounded by metal screens. Underneath the stairs are secret compartments. In front of *No Exit* two wooden balls

—insinuatingly hoary and riddled with cracks—guard the staircase like master accomplices in power. A nihilistic setting of desperation and sheer loneliness, this is not Nancy Drew's hidden staircase; it is Sartre's locked room where relationships cannot be established and, as he concluded, "Hell is other people."

Not only Sartre, but also his colleagues Camus and Giradoux understood that in a malign world defiance of senseless authority offers the only possible exit from mental and social imprisonment. Remembering the past, Louise Bourgeois dramatically captures a state of mind even as America, heading into the twenty-first century, is shaking up petrified beliefs and customs.

Coming from early childhood memories, the stairs that she hid behind to see what others were up to belong to her iconography of the house and its flow of figures. Intimately appraised by Bourgeois, these figures cast uneven shadows on her unconscious. Memories real, memories imagined, memories blurred. Within the flickering shadows, figures continue the struggle to survive. *Ventouse* (1990), a carved chunk of black marble, is topped with bulbous glass forms that connect to her breast-phallus imagery. Electrically lit, the elements are glass cupping jars (*ventouses*) once used by physicians for sucking blood to the skin's surface. The treatment was supposed to cure various ills: Louise put them on her mother's back in a futile attempt to cure her emphysema. *Ventouse* symbolizes helping someone stay alive even when there is no hope. Her sculpture, chiseled and hammered and nailed with layers of memory, as well as dreams of hope and nightmares of hopelessness, may seem confusing, too other worldly at times. She doesn't care. It's like inventing a new language. "Some get it, some don't. You can say the same thing about Chinese."

Only tomorrow is interesting, Bourgeois stoutly claims, though she is tied to the past. It's unresolved. "If we are very compulsive," she has confessed, "all we have at our disposal is to

Louise Bourgeois

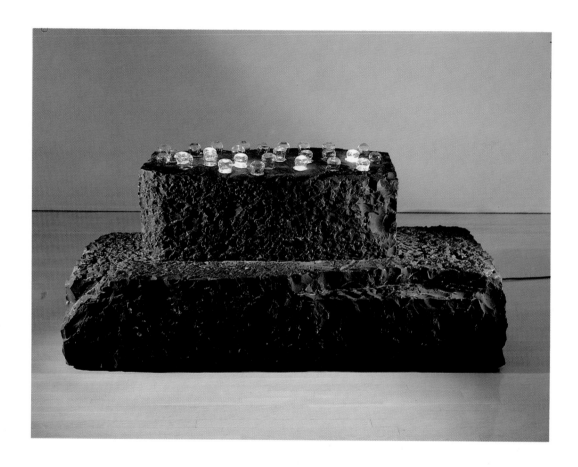

Ventouse
1990
Marble, glass,
and electric light
34 x 32 x 78 inches
Photo: Peter Bellamy
Courtesy Robert Miller
Gallery, New York

repeat." Little Alice insisted that what she said three times was true. Bourgeois feels that whatever she has to say must be repeated at least six times to make herself understood. Repetition is refinement, another attempt to solve a problem. Beyond the mystery of language, she reiterates, the act of sculpting is an exorcism for her. She wants to blot out images she finds herself repeating and refining. But in the locked room, in the locked heart, there is an unfor-

giving hurt that can't get out. The obsessive quality does not result in a transcendence of her emotions.

The art historian Kevin Eckstrom, later a curator at Storm King in 1991, was completing his essay on her when he died unexpectedly at the age of thirty-six. He found that "her imagery, by its repetitive nature, doesn't provide a catharsis. Railing against the circumstantial fragility of life and its cruelties," she remains dependent, he reasoned, on the memories that oppress her. And her objects are emblems of solitary pathos. Robert Rosenblum agrees with his conclusion that there is no catharsis or exorcism. "Isn't an exorcism just once?" he asks, "Unless it doesn't take the first time. Her obsessions feed her art. I think Louise should just say she's *grooving* on them."

Her art enthralls because its natural expression conceals nothing. It yearns and battles and clamors for deliverance. And because she is overwhelmed with memories, some distorted by the looking-glass, her work, even when most raw and obsessive, alarms our own imaginations. She is obsessed with recall, yet knowing it may not be accurate, she welcomes *Partial Recall* (1979), an assemblage of ten rows of ascending semicircular wood pieces, all painted white, signifying the chance to start over. Again, the undulating image connects to her motif of eyes and clouds. But she cannot resist a slight ambivalence, so the calming clouds also suggest tombstones in a crowded graveyard. "Art is more interesting when it is disturbing and you don't know why," says Louise Bourgeois.

Her work demonstrates that she seeks not only deliverance but also connection. She is absorbed by a desire to connect, which everyone desperately seeks. When people cannot connect, there is pain and frustration and hurt. Insistent words, carved naively and directly on two pink marble pieces, express that first pure contact with life and emotions: *Do you love me?* and *I love you.*

Louise Bourgeois

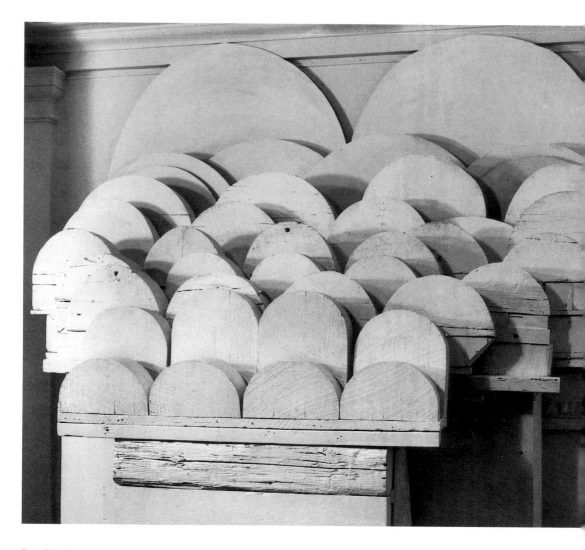

Partial Recall, 1979, Wood, circa 100 x 90 x 66 inches
Photo: Bruce C. Jones, Private Collection

Inside her Brooklyn studio, Bourgeois puts down a tool and reads a communiqué. Another museum show is being planned; the art world cannot seem to get enough of her. The season is now summer. She gazes out the windows at the sky. It is pale blue with ribbons of pink, the color of a Paris sky when the Luxembourg Gardens are ablaze with flowers. As she raptly contemplates a silvery speck of cloud in the limitless expanse, a dauntless and stoical look crosses her face. The past has prepared her for the rigors of the future, but right now she is living in the present. The present is very good.

Irresistibly, she is drawn to a far corner of the studio, where she examines *Clouds and Caverns*, an in-progress environment of wood and sheet metal cut into half-circles (or three-dimensional arcs) and stacked on ascending wooden platforms. There are about twenty-five pieces—which she's still arranging—and it's rather like a floating stage set, twenty feet across, that can be walked around. The "clouds" almost reach the ceiling. She smiles contentedly. "All artists try to make sense out of chaos. Here is a logical and coherent world. The opposite of closing oneself off. I'm not used to paradise, but it's nice to visit now and then."

On a side table are masses of wooden forms—miniature tombstones cut on a band saw and smaller sheet-metal arcs, with the wooden elements placed inside. Not today, but some day, or maybe never, she will fit them into her setting. She fondles a tombstone. "No—no—I'm not sure yet where they will go. Nowhere, perhaps. We can say that conceptually this piece is finished except for one thing." She goes to a bin of found objects, rummages through an assortment of cast-offs and retrieves a saucy pink mannequin leg. Her eyes travel up and down the big environment. Then she places the leg at the bottom of the lowest platform. "Finished! The leg represents the right to be facetious." she looks up with a blissful sigh and says, "It is necessary to have some fun in paradise."

Louise Bourgeois

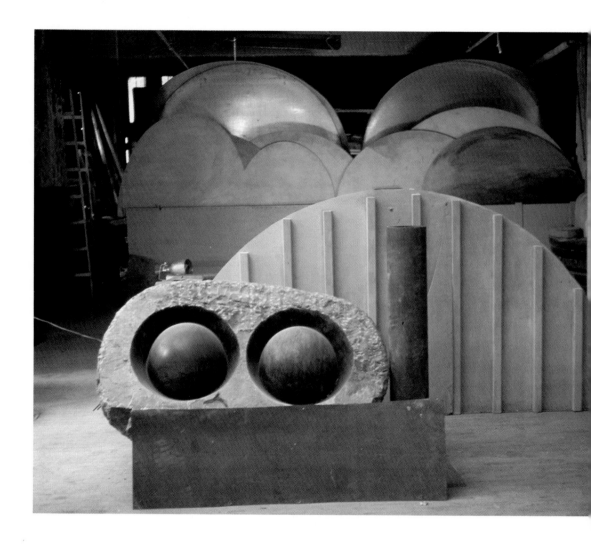

Clouds and Caverns
1982–89
Courtesy Michael McLaughlin

"The artist tries to become an adult, but never loses his innocence—that's what
makes him an artist. With innocence, the artist expresses what others are terrified of."
Photo of Louise Bourgeois by Berenice Abbott, Courtesy Robert Miller Gallery, New York

Selected

Bibliography

Alloway, Lawrence. *Art in America.* May–June 1976.

Batille, Georges. *Eroticism.* London: Calder, 1962.

Bourgeois, Louise. *Balcon.* Madrid: Antonio Zaya, 1991.

Brenson, Michael. *The New York Times.* August 6, 1990.

Conrad, Joseph. *Lord Jim.* New York: Doubleday, 1931.

Conway, Madeleine and Nancy Kirk. *Artists' Cookbook.* New York: Museum of Modern Art, 1977.

Cowley, Malcolm. *Exile's Return.* New York: Viking, 1951.

Dahl, Roald. *Tales of the Unexpected.* New York: Vintage, 1990.

Gorovoy, Jerry. *The Iconography of Louise Bourgeois.* New York: The Max Hutchinson Gallery, 1980.

Hughes, Robert. *Time.* November 22, 1982.

James, Henry. *Italian Hours.* New York: Ecco Press, 1987.

Jullian, Philippe. *Montmartre.* New York: Dutton, 1977.

Kuspit, Donald. *Bourgeois.* New York: Avedon/Vintage, 1988.

Larson, Kay. *Artnews.* May, 1981.

Lippard, Lucy R. *From the Center.* New York: Dutton, 1976.

Marandel, Jean P. *From the Inside.* Chicago: Renaissance Society, 1981.

Maupassant, Guy de. *A Woman's Life.* New York: Penguin, 1986.

Meyer-Thoss, Christiane. *Louise Bourgeois.* Zurich: Ammann, 1992.

Morgan, Stuart. *Artscribe.* January, 1988.

Nathan, George Jean. *The House of Satan.* New York: Knopf, 1926.

Rubin, William. *Louise Bourgeois.* New York: The Museum of Modern Art, 1982.

Russell, John. *The New York Times,* February 11, 1974.

Sartre, Jean-Paul. *No Exit.* New York: Knopf, 1946.

Seiberling, Dorothy. *New York Magazine,* February 11, 1974.

Storr, Robert. *Louise Bourgeois Drawings.* New York: The Robert Miller Gallery, 1986.

Wharton, Edith. *A Backward Glance.* New York: Appleton-Century, 1934.

Index